IMAGES
of America

MASSENA

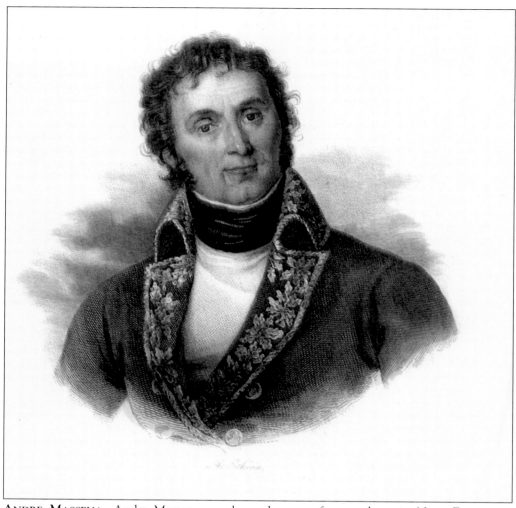

ANDRE MASSENA. Andre Massena was born the son of a merchant in Nice, France, on May 6, 1758. When he turned 17, he enlisted in the Royal Italian Regiment, and eventually retired in 1789. Two years later, Massena rejoined the army, and by 1796 he was adjutant of the 3rd battalion of the volunteers of the war. In Napoleon Bonaparte's campaign (1796–1797), Massena became Napoleon's most trusted general. In 1802, Andre Massena was made one of the first marshals of France. In the Peninsula Campaign of 1810 at Wellington, Napoleon and his army were defeated, and they returned to their country in disgrace. Massena died on April 4, 1817, and was buried in Perela-Chaise, the Valhalla of Parisian notables. He only had "Massena" etched on his tombstone. In northern New York state, the largely French population of one community chose to name their town Massena when it was incorporated in 1802. However, Andre Massena never visited the area.

IMAGES
of America

MASSENA

Theresa S. Sharp and David E. Martin

ARCADIA
PUBLISHING

Copyright © 2005 by Theresa S. Sharp and David E. Martin
ISBN 978-0-7385-3693-4

Published by Arcadia Publishing
Charleston, South Carolina

Printed in the United States of America

Library of Congress Catalog Card Number: 2004110295

For all general information contact Arcadia Publishing at:
Telephone 843-853-2070
Fax 843-853-0044
E-mail sales@arcadiapublishing.com
For customer service and orders:
Toll-Free 1-888-313-2665

Visit us on the Internet at www.arcadiapublishing.com

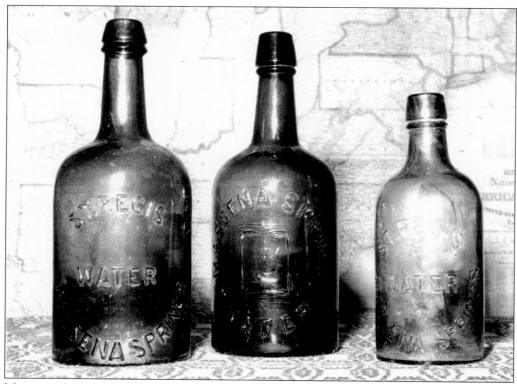

MASSENA SPRINGS BOTTLES. After the Massena Springs resorts faded away, there were still many requests for mineral water. The water was bottled from the springs and sold by druggists and mineral water dealers throughout northern New York. These three types of early St. Regis or Massena Springs mineral water bottles were once shipped to New York and Boston, among other U.S. cities. The bottles ranged in color from the earliest blue-green to brown to white and then clear. The Massena Museum has a few of these bottles in its possession.

CONTENTS

ACKNOWLEDGMENTS

We would like to thank the Board of the Massena Museum for their cooperation with the publication of this book.

The following people donated their time and talents to this project and we, the authors, would like to thank them: Vera LaRoe, editing and typing; Sally Yeddo, research and typing; Rebecca Geisor, typing; and Athenia Rufa, typing.

We would also like to thank the following people who contributed images from their personal collections: Virginia White Clary, Michael Francia, and Pauline Boyce. Except where noted, all images in this book were taken from the archives of the Massena Museum.

INTRODUCTION

Due to its isolation, the northern area of New York was among the last regions of the state to be settled. The land that now holds the village of Massena was first occupied by people other than American Indians in 1792, when lumbermen arrived from Montreal to build a dam and construct a lumber mill on what is now known as the Grasse River. Annabel Faucher leased the land from the St. Regis Indians. It was the location of the mill. This part of the state was carpeted with vast virgin forests of assorted hardwoods, and the lumber industry flourished in the area. As more settlers entered the area, people diversified their needs and an agrarian lifestyle soon became predominant.

Massena was incorporated on March 3, 1802. The name was chosen by the town's large French population in honor of Marshal Andre Massena, who was famous in Europe as a soldier in Napoleon's army.

The Massena area had natural sulfur springs that attracted many visitors from all over to drink the water that they hoped would effect a cure for their medical maladies. Big hotels soon sprang up to accommodate the influx of people, and a major tourist area developed. After 1900, the mineral waters fell out of vogue, and the mineral springs lapsed into a state of decline, until 1932, when the last big hotel, the Hatfield House, was destroyed by fire.

The next major change in the area was brought about by an idea credited to H. H. Warren in the mid-1890s. Warren noticed a considerable difference in elevation between the St. Lawrence River and the village of Massena. Warren consulted with Abron Mann, an engineer, and Charles R. Higgins, a mill owner, regarding the feasibility of a canal for the production of electric power. Later, Michael H. Flaherty and Charles A. Kellogg became partners in the enterprise. They obtained the right of way and an advantageous charter for the excavation. The St. Lawrence River Power Company was incorporated in 1896.

The project was started by the Lehigh Construction Company of Lehigh, Pennsylvania, and the first shovelful of dirt was dug from the ground on August 11, 1897. The Lehigh Construction Company withdrew from the contract in the fall of 1897, and the T. A. Gillespie Company took up the task and completed digging the power canal. Upon completion of the power canal, work was started on the powerhouse, gatehouse, and retaining walls, completing the work in 1903.

To complete this massive project, many hundreds of laborers were required. Men came from Italy, Ireland, France, and other parts of Europe. Many were skilled carpenters, masons, engineers, and surveyors, and many labored at the back-breaking task of moving hundreds of

thousands of cubic yards of dirt and rock. As the task neared completion, many of the workers who had saved their wages brought their families from Europe to live in America. In so doing, the workers added their ethnic and cultural diversity to the area.

Diverting water from the St. Lawrence River through a canal to a power-generating station placed Massena in a position to become one of the major manufacturing centers of the state. The project produced cheap and voluminous quantities of electric power. This was the perfect opportunity for a company such as the Pittsburgh Reduction Company, which opened in Massena in 1902. The Reduction Company hired many of the workers that stayed after the completion of the power canal project. A railroad was also brought to the area to facilitate moving material in and out of the industrial complex, and Massena continued to prosper.

The Pittsburgh Reduction Company's name was eventually changed to the Aluminum Company of America (Alcoa). The Massena plant produced much of the aluminum sheeting, as well as structural aluminum, required for the construction of planes during World War II.

While so many men were off to fight the war, hundreds of women took up their jobs in the factories and shops, and thus there was no interruption or decrease in the production of the aluminum needed for the war effort.

In 1957, the St. Lawrence Seaway and Power Project was completed and made worldwide shipping possible between the Great Lakes and the Atlantic. The power project produces much of the power needed by the northeastern United States and the southeastern part of Canada. The Massena area is an important tourist destination that is good for local economies. There remains room for further development, and what lies in store for the future of Massena remains to be seen.

One

MASSENA SPRINGS

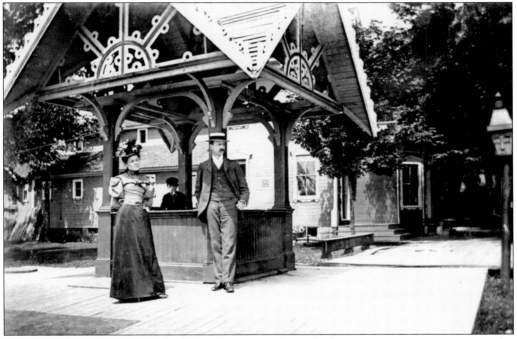

MASSENA SPRINGS. In 1785 the government dispatched a survey party to inspect the 10 townships of St. Lawrence County. There, the group met members of the St. Regis tribe, who led the party to the mineral springs of Massena. The American Indians described the springs as "water coming out of the ground that smelled badly, where the moose, the deer and sick Indians came to lick the water." Eventually, the springs made Massena famous as a health resort. People first used the water because of the medicinal properties associated with the water's sulfur content. By 1813, invalids were coming to Massena for a cure. Capt. John Polley built the first public lodging house in 1822. Benjamin Phillips became proprietor of the springs in 1848 and erected the U.S. Hotel, which was destroyed by fire in 1871 and then was replaced by the Hatfield House. Ruel Taylor built the Harrowgate House for Parson Taylor in 1898. After the original promoters died, the property was neglected and the hotels burned down. For a few years after that, former guests continued to order shipments of the health-giving water from local merchants. Shown is the site of the springs during its heyday.

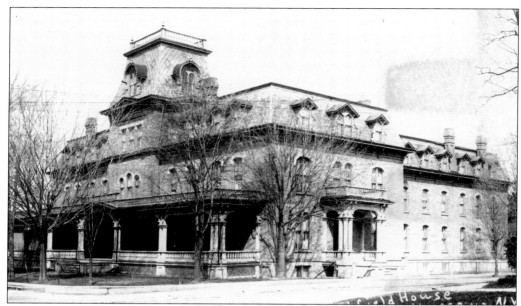

THE HATFIELD HOUSE. The Hatfield House, built by New York tea broker Abraham Hatfield, was constructed at a cost of more than $75,000. In 1871, a fire destroyed the United States Hotel, which had previously occupied the Hatfield's parcel of land. The Hatfield House was a three-story building with 90 rooms, as well as a full basement and a fourth-story observation tower. During the summer months, this fine hotel was the scene of many parties. Guests from larger cities came to Massena to drink from the springs.

THE HARROWGATE HOUSE. The Harrowgate House was built in 1829 by Ruel Taylor. It was located on the corner of South Main Street and West Hatfield Street, near the famous mineral springs. The old Harrowgate Hotel was known as one of the most hospitable of the summer resorts. The hotel was owned and operated by W. R. Stearns. The season for the hotel began in early summer and lasted until the frosts of autumn arrived.

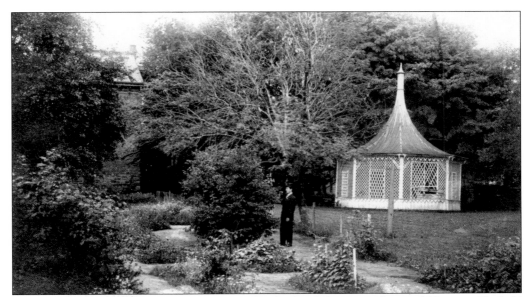

THE PAVILION AT HATFIELD HOUSE. In the back of the magnificent, 110-room Hatfield House stood a pavilion, where people could sit and enjoy the beautiful garden flowers and paths. The garden featured roses, peonies, chrysanthemums, and several other varieties.

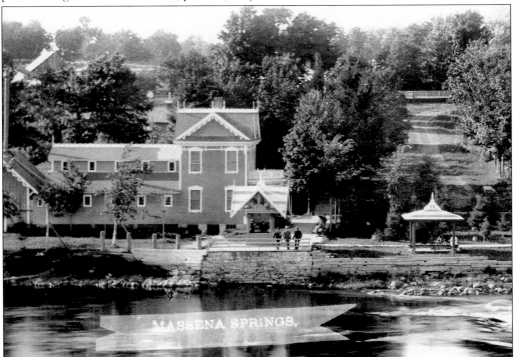

MASSENA SPRINGS.

THE SPRINGS BATHHOUSE. This view shows the pavilion in front of the bathhouse. The bathhouse had a smaller boiler house behind it that fed the heated water through wood pipes to 10 cubicles with tubs. They were equally divided for male and female use. To the right is another fountain. David Stearns built the bathhouse.

11

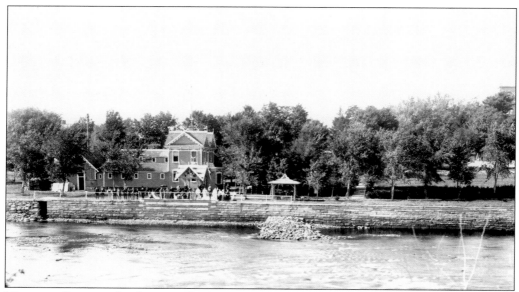

MASSENA SPRINGS. Looking north, this view across the Racquette River shows the buildings that accommodated visitors to the Massena Springs.

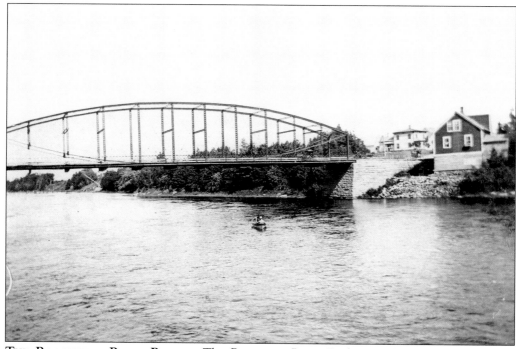

THE RACQUETTE RIVER BRIDGE. The Racquette River Bridge was located at the end of Douglas Road. Later on, the bridge was replaced and was moved to South Main Street, near the Springs Park. The piers of the bridge are still visible from the Springs Bridge. The Massena Springs Bridge accommodated the many visitors that came to the springs for cures after the railroad arrived in 1886.

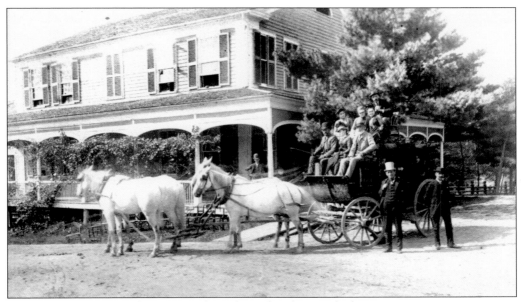

THE STAGECOACH. Before 1886, when the railroad arrived, there was no passenger service to or from Massena. In 1883 the stagecoach picked up passengers and mail at the Harrowgate Hotel, and then traveled down dusty, sandy roads to Norwood to catch the train at the railhead. It was a 15-mile trip, requiring two and a half hours, and often travel was so rough that some passengers would get out and walk.

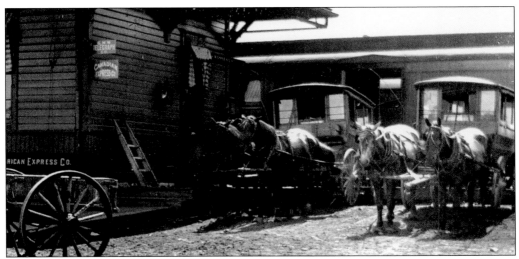

THE STAGE COACH AT MASSENA SPRINGS RAILROAD DEPOT. In 1886, the first railroad came to Massena only from the west, when the line was extended from Norwood. In 1888, the Grand Trunk Railroad extended the line from Fort Covington to Massena, giving Massena east–west service. These buses, as they were called, were horse drawn and hauled freight in open-sided vehicles or passengers in closed-sided vehicles.

THE RAILROAD. On May 24, 1883, the United States and Canada Railroad Company was incorporated under the laws of New York state. The Massena Springs and Fort Covington Railroad Company was incorporated September 10, 1884, and attempts were made to bring the line through to Massena. The first passenger train arrived in 1886, and regular schedules were established. A group of dignitaries inaugurated the railroad in front of the Harrowgate Hotel in Massena Springs.

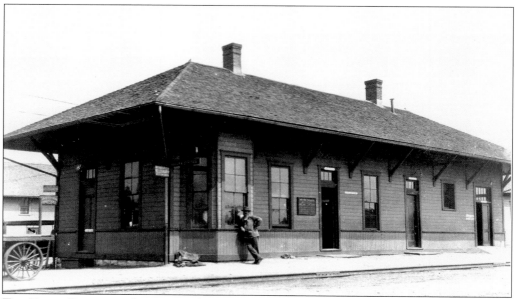

THE EARLY RAILROAD STATION. When railroad travel was in its heyday, railroad stations such as this one at Massena Springs were a common sight. This station was built in 1916 when the old depot was moved across the tracks. The C.N.N. Telegraph Company, the Canada Express Company, and the Western Union Telegraph Company were all located in this building.

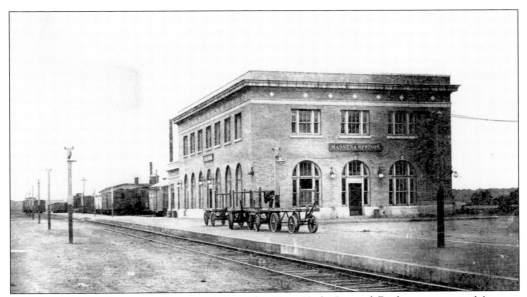

THE NEW YORK CENTRAL DEPOT. When the New York Central Railway came to Massena Springs, it was necessary to remove the old depot and pull up some of the old track to make room for a new station. The new structure was located on the west side of Main Street near the present freight house.

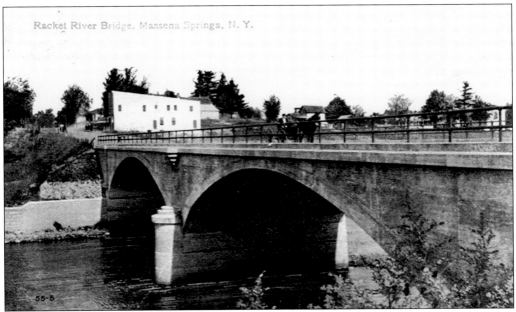

Racket River Bridge, Massena Springs, N. Y.

55-5

THE MASSENA SPRINGS POST OFFICE. Like many of the early post offices, the Massena Springs post office was located in a general store at the springs. George Dutton was postmaster. Beginning in 1879, it was designated as the Hatfield, New York, post office, but was changed to Massena Springs after the arrival of the railroad in 1886. Here, the store and post office can be seen at the end of the Racquette River Bridge.

JOHN L. SULLIVAN. John L. Sullivan was a world-famous bare-knuckle boxer. His family had a home in Massena Springs that was located on the site of what was known as the Triple A Lumber Company. Sullivan was attracted to the Massena Springs area and spent the summer of 1900 there. He frequented the Hatfield House for entertainment and socializing.

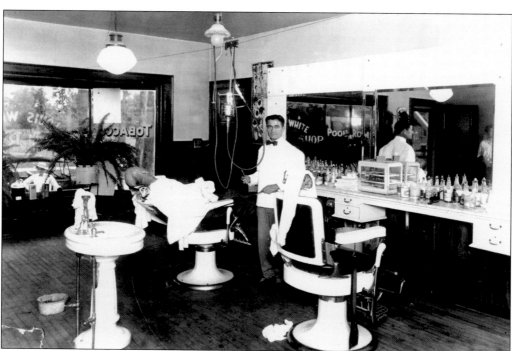

LOUIS WHITE'S BARBERSHOP. Louis White's Barbershop and Poolroom was located at 407 Main Street, near the intersection of Hatfield and Main Streets. He was born Louis Bianchi in Italy and emigrated to the United States in the early 1890s. He raised a family of nine children above the shop. In the back of the barbershop was a poolroom with two billiard tables. The White family started a taxi service in Massena. (Courtesy of Virginia White Clary.)

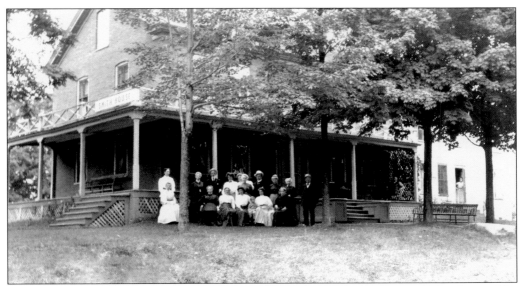

THE SMITH HOUSE. This house, built in 1822 by Capt. John Polley, was the first public building in Massena Springs. Many guests returned every year to take advantage of the inn's special accommodations for people who wanted a quiet, relaxing environment. Originally known as the Polley House, in 1869 the name was changed to the Smith House after Ebenezer Smith bought the property.

THE ROSE COTTAGE. Mr. Rose from Morrisburg, Ontario, loved to come to the Massena Springs, so he built this cottage on the southeast corner at the intersection of Main and Hatfield Streets. His family had no interest in the house after his death, and the cottage was rented to Theodore Pine. Pine came from a family of British portrait painters. He added a studio to the house and created portraits of such people as Robert E. Lee and Ulysses S. Grant.

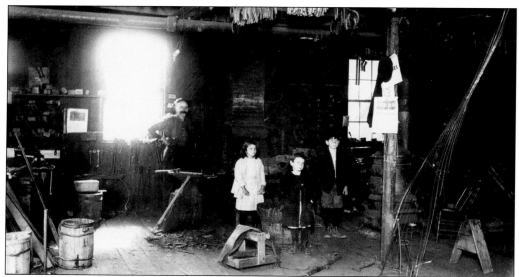

THE BLACKSMITH SHOP. From 1900 to 1918, Antwine Cardinell owned and operated the blacksmith shop on South Main Street. After his death in 1918, his son Alexander inherited the business. He followed in his father's footsteps and continued operation of the shop. Here, Antwine Cardinell (at back) is pictured with three young helpers.

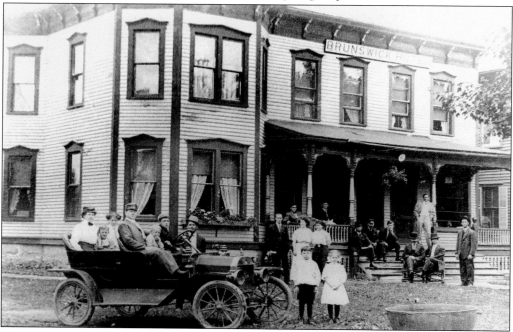

THE BRUNSWICK HOTEL, 1910. This hotel was built in 1895 by Irving G. Hamilton, and was originally known as the Hamilton House. After construction started on the Massena Canal, the property was taken over by Peter D. Bonin. He changed the name from Hamilton House to Brunswick Hotel and opened for business in 1897. John L. Sullivan, the famous boxer, was a frequent guest in 1901. Following the enactment of Prohibition in the 1920s, the Brunswick Hotel was converted to a boardinghouse. It was demolished in 1969 after a fire.

18

Two

THE MAIN STREETS

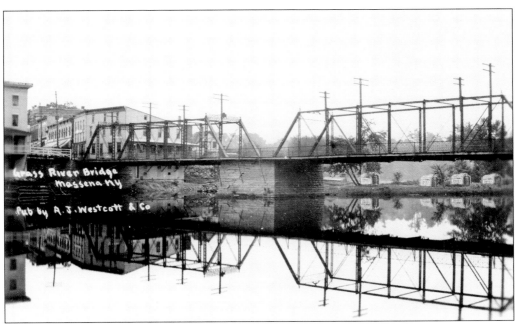

THE ORIGINAL GRASSE RIVER BRIDGE. Originally a covered bridge spanned the Grasse River to link Main and North Main Streets. Most covered bridges were wooden structures that were often vulnerable to destruction caused by fires or spring floods. The covered bridge in Massena was replaced in 1889 by a structure consisting of two iron spans covered with wood planking.

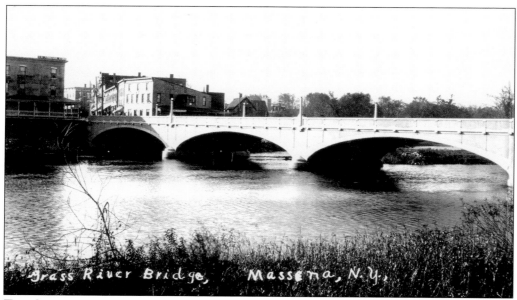

THE CURRENT GRASSE RIVER BRIDGE. In 1929 the iron bridge was replaced by a concrete one, which was recently refurbished between 2003 and 2004. New concrete railings in the Mission style replaced the rusted metal sides.

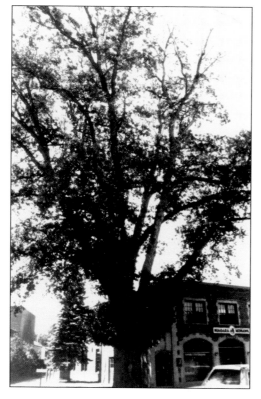

THE BURR OAK ON MAIN STREET. This famous Main Street landmark, which stands near the old Niagara Mohawk Building, is believed to be 163 years old. When the tree was measured in 1971, it was 14.8 feet in circumference, 60 feet high, and had a 75-foot crown. This Burr oak is one of the last remaining large trees in the downtown area of Massena. The tree was planted by Thomas Burney and his wife on the same lot on which they built their home.

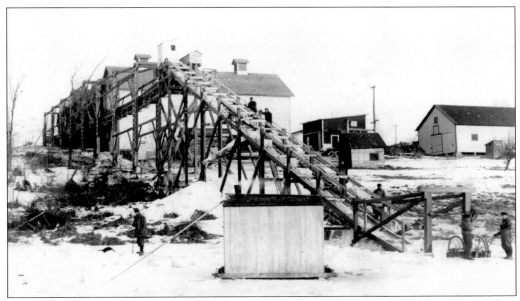

ICE HARVESTING. The first ice company was established in 1893, and was located at 25–27 North Main Street. It was named the Massena Ice Company and was founded by Elon A. Horton. Over a period of 30 to 60 days during the late winter, the ice was cut from the Grasse River, one block above the Main Street Bridge. The ice was stored in sawdust in sheds on George Street.

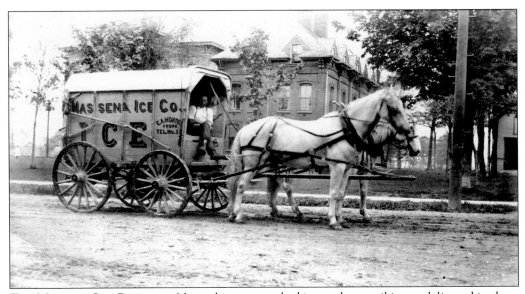

THE MASSENA ICE COMPANY. Natural ice was packed in sawdust until it was delivered in these vans from storage sheds to customers around Massena. Floyd Horton took over the natural-ice business from his father and operated it until he sold the company to Alex Krywanczyk, who installed ice-making machines.

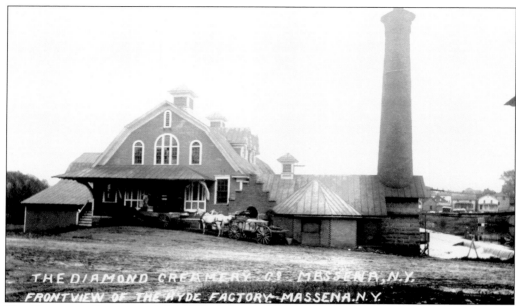

THE DIAMOND CREAMERY. This photograph shows the Diamond Creamery, which was located on the banks of the Grasse River. On the left is the curd mill and on the right is the butter factory. The Diamond Creamery was abandoned in 1918. The Mica Company of Canada started operations in the creamery in 1923, and by 1942 it employed 100 persons. The business closed in 1948, and the building burned to the ground in 1956.

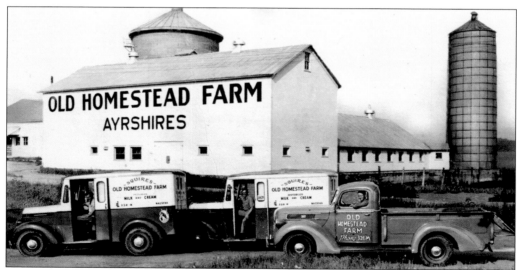

THE HOMESTEAD DAIRY. The Homestead Dairy began operation in 1918 at the old Homestead Farm on Route 56 just outside of Massena. The milk was delivered in glass bottles several times a day. In 1944, the plant moved to its present location on Curtis Street. During the second World War, Robert S. Squires teamed up with another area dairy man to help the business survive. After three generations of Squires family ownership, the business was sold to Upstate Farms Cooperative in the 1990s.

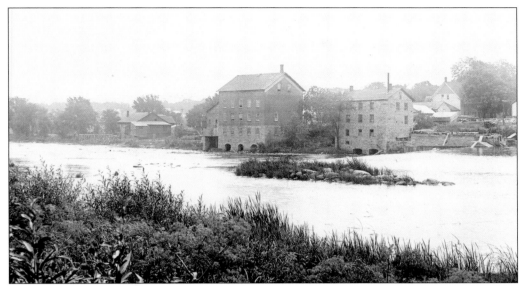

THE GRASSE RIVER MILL. The potential waterpower of the Grasse River is what attracted the first white settlers to the village of Massena. Many of those newcomers set up residence on Water Street (formerly known as Mill Street). The first settlers were Frenchmen, who leased land by the river from the St. Regis Indians. The settlers built the first dam, erected mills, and engaged in an extensive lumbering business. The Grasse River, a tributary of the St. Lawrence River, is located entirely in St. Lawrence County.

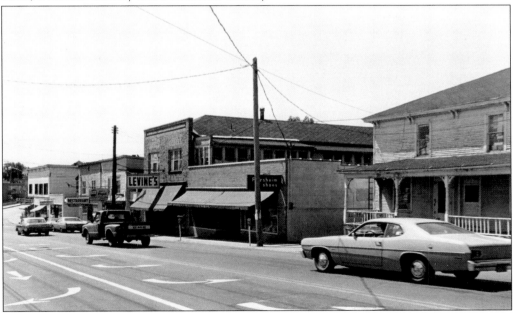

LEVINE'S CLOTHING STORE. Levine's store, located on North Main Street, was a part of Massena for so long it became classified as a Massena institution and landmark. For many years, the Levines had been the best known of all the merchants in the area, and their fine reputation had been earned through years of service to their customers and the community. The building was demolished in 2003.

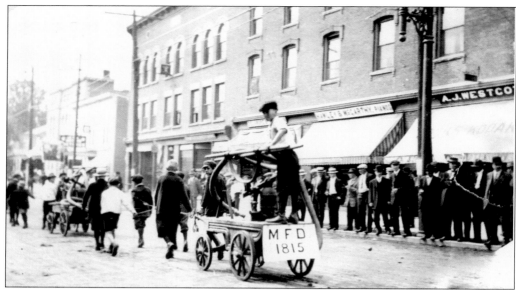

WESTCOTT STATIONERY STORE. Arthur J. Westcott Sr. was the founder of the Westcott Stationery Store (at far right). In 1908, Westcott came to Massena and established his first store in the Ball Block on Main Street. He operated the Massena Postal Telegraph Office, built the first radio receiver in Massena, owned one of the first cars in town, and operated the first full-service camera store. The photographs of early Massena were taken by Arthur J. Westcott Sr., and many were donated to the Massena Museum.

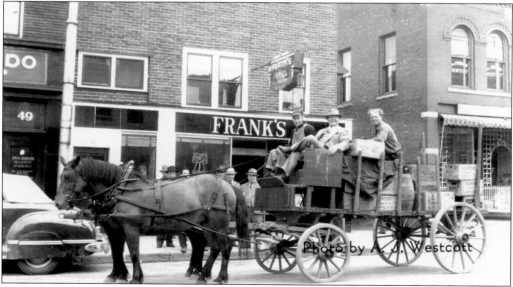

MAIN STREET, 1933. Jim Hammill and Sam Cappione are seated at the front of an old delivery wagon on Main Street in 1933. (The passenger at the back is unidentified.) Some of the Main Street storefronts can be seen in the background. Over Frank's store were the offices of Dr. A. J. Smith, optometrist, and Dr. L. Ingram, dentist. Over Westcott's store was Dr. Johnson's dental office. On the left was Cook and Montondo's men's clothing store. Clark Cook later became one of Massena's town clerks.

COOK AND MONTONDO MEN'S CLOTHING STORE. For many years, Clark Cook was employed in the clothing store of Friedman and Rosenbaum. Cook later started his own clothing store with Leo Devine. That partnership ended in 1941, and Cook went into partnership with Ralph Montondo. Cook sold his interest to Montondo in October 1941. Montondo closed the store in 1959.

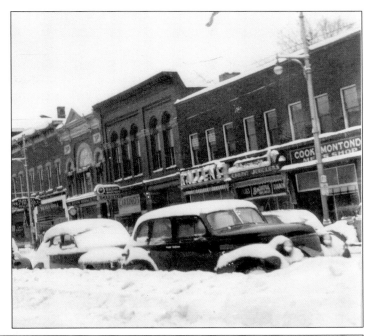

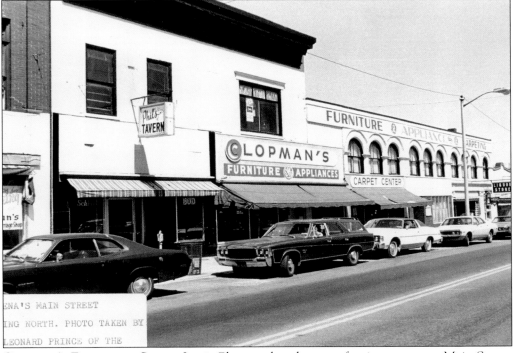

CLOPMAN'S FURNITURE STORE. Louis Clopman bought out a furniture store on Main Street. He built a new building on Water Street and opened in February 1929. In 1945, his son joined the business. In 1956, the business was moved to its present location on Main Street, and Louis's grandson joined the business after graduating from college. Carloads of furniture arrived at Massena Railroad Yard at Massena Springs.

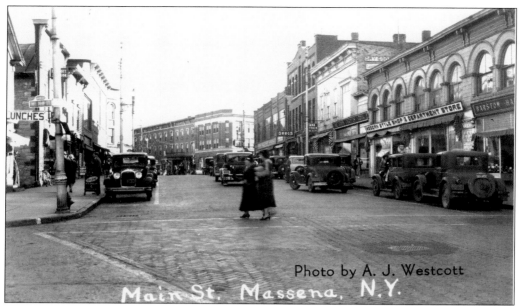

Photo by A. J. Westcott

Main St. Massena, N.Y.

MAIN STREET, LOOKING SOUTH FROM THE WATER STREET CORNER. Old cars line the street on both sides. Two ladies cross the street, perhaps headed to the luncheonette for afternoon tea. The herringbone brick pattern is seen prominently on the road.

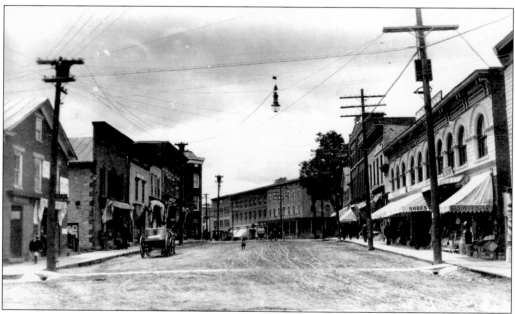

MAIN STREET BEFORE 1923. The light for the street is shown in the center of picture. On the right is the St. James Hotel, a dress shop, and a shoe shop. On the opposite corner is the White Hotel. The streets were paved in 1923. The streetlight hung from a wire in the center of the picture. Town residents enjoyed watching the horse races that were sometimes held on Main Street.

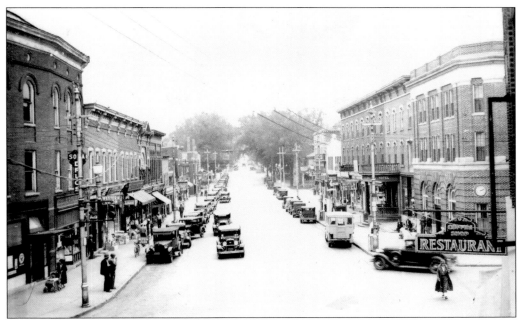

MAIN STREET, LOOKING SOUTH. On the right side of the street is White's Hotel. On the left side there is a drugstore and a Western Union office. Also, a woman pushing a wicker stroller can be seen in the left foreground.

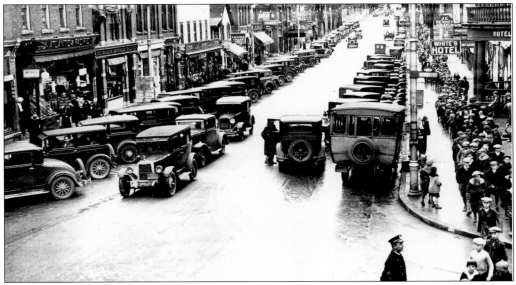

HUBBARD'S BUS LINE AND AUTO LIVERY. The bus line operated out of Maple Street and was owned by E. C. Hubbard. Buses ran daily to Ogdensburg and Malone via Helena, Brasher, Lawrence, and Moira. Buses left Massena at 7:30 a.m. and met all trains into and out of Massena. Hubbard's also offered a first-class livery of five- and seven-passenger cars for connection service.

THE CORNER OF PHILLIPS AND MAIN STREETS. The large building in the foreground was formerly occupied by Clark's Hardware Store, which was owned by Henry P. Clark. After Clark died, he left half of his income to Massena Memorial Hospital and a scholarship fund to help finance further education for youths. The scholarship was established in memory of his parents, Henry T. and Electra Phillips Clark.

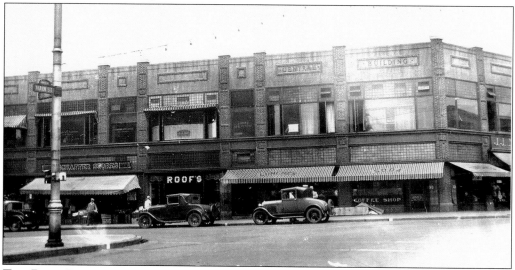

THE ROOF JEWELRY STORE, IN THE CENTRAL BUILDING. Mr. and Mrs. John R. Roof came to Massena in 1917 to operate a jewelry store in the Central Building, which had just been completed. In 1934, Mr. Roof closed his store and opened the Club Restaurant at the corner of Main and Andrews Streets. After the Roofs sold the restaurant, Mr. Roof was a caterer at the Massena Country Club for several seasons. He died in 1967.

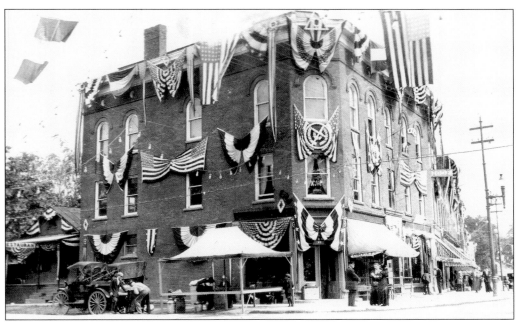

MAIN STREET, THE SMITH BLOCK. The brick building located at the corner of Main Street and Phillips Street was erected by Hiram E. Smith. After the building's construction was completed in 1898, Smith moved his grocery business into the corner storefront on the ground floor. A women's shop was located in the middle storefront of the building, and the third store on the ground floor eventually became B. O. Kinney's drugstore. The second floor of the Smith Block was occupied by a lawyer's office, and the third floor was a public hall. In 1988, Key Bank purchased and demolished the building, and installed a small recreational park on the site.

THE KINNEY DRUGSTORE. Burt Orrin Kinney was born on September 12, 1873, in Gouverneur. Burt's mentor and boss, A. W. Dewey, a druggist, encouraged the hardworking young man to enroll in the Albany School of Pharmacy. Kinney started pharmacy school in 1899, with Dewey footing the bill. Two years later, Kinney was filling prescriptions in Dewey's store. In the fall of 1903, Dewey sold his store to his protégé. In 1928, Kinney opened a store in Massena.

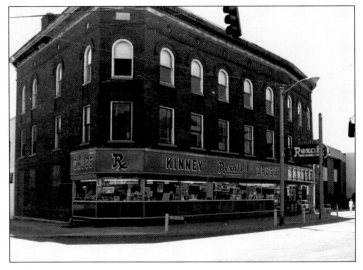

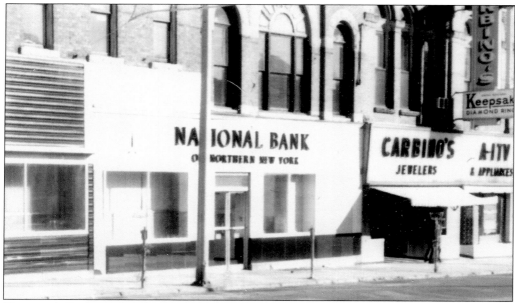

CARBINO'S JEWELRY STORE. David Carbino's jewelry and appliance store was a family business that dated all the way back to 1897. David's grandfather (also named David) established the jewelry store, and David's father, Irving, entered the business in 1927. David opened his own appliance and television store right next door to Carbino's jewelry in 1958. One of David's sons, Gregory, operates Carbino's jewelry stores in Potsdam and Ogdensburg. The Massena jewelry store was closed.

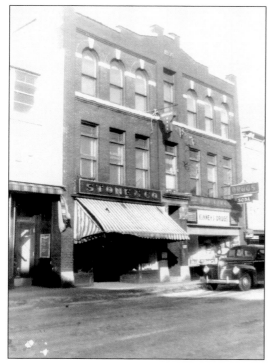

THE STONE AND COMPANY CLOTHING STORE. The Stone and Company store sold merchandise that was very expensive and elegant. Eli Friedman was the proprietor of Stone and Company in Massena for 56 years, retiring in 1962. Friedman was born in May 1893. He was educated in Massena schools and attended Cornell University. He died in 1981.

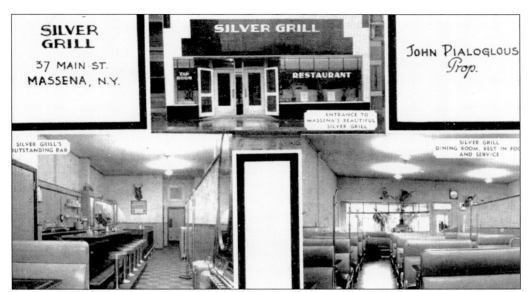

THE SILVER GRILL RESTAURANT, MAIN STREET. John Pialoglous opened the Silver Grill on Main Street and the New Ero across the street around the same time. He came to this country from Greece and worked in large hotels in New York City before coming to Massena in 1919. Pialoglous opened his first restaurant on Phillips Street. Later, he oversaw the dining room in White's Hotel, and was the proprietor of the old Boston Lunch, which was destroyed during the White's Hotel fire.

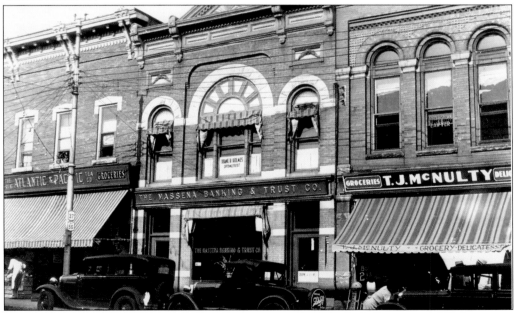

T. J. MCNULTY'S GROCERY AND DELICATESSEN. T. J. McNulty's Grocery and Delicatessen was located on the east side of Main Street. McNulty spent his mornings calling on customers in the area around Pine Grove, East Orvis Street, and Elm Circle. Clarence Sharlow, who worked for McNulty, took orders and then delivered the groceries in a wagon. The wagon horses were stabled in Horton's barn on North Main Street.

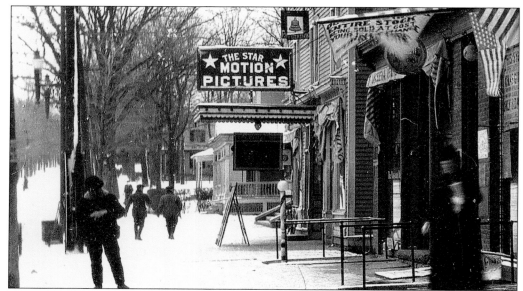

THE STAR THEATER. In 1913, V. A. Warren decided to construct a theater on Main Street across from Schine's Theater. The Star Theater was opened to the public on June 28, 1913. Some years later, the building was expanded so that there were exactly 1,200 seats. Warren was in charge of the new theater until he leased it to the Schine Organization in 1926.

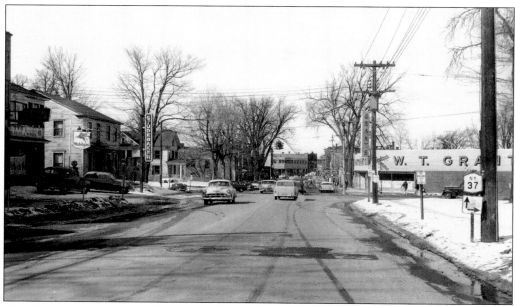

THE FORMER SITE OF THE KIRKBRIDE HOME. The Kirkbride House, which was distinguished by its big cupola, was situated on the north corner of East Orvis and Main Streets. The home was built in 1879 by Frederick G. Kirkbride, a native of Philadelphia, New York. Kirkbride established a store at the lower end of East Orvis Street. The Kirkbride House was razed to make way for the W. T. Grant store (in photograph, on right), and that building was later demolished so that a Rite Aid drugstore could be constructed on the site.

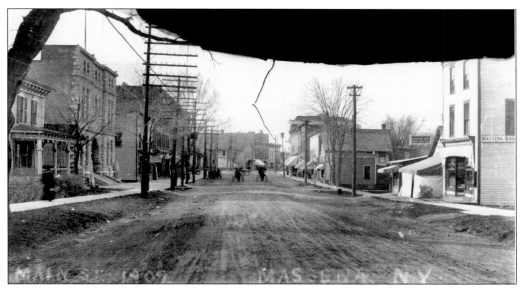

MAIN STREET, 1909. This view of Main Street shows many of the changes brought on by the power canal and Alcoa. Seen on the right side of the street are Raymond's Bakery, the Peppino and Napoleon Marando Brothers Store (famous for its fruit and sodas), a shoe store, and a small building where Henry Danforth sold newspapers. On the left side is the Clint Erwin House (home to two mayors), the new town hall, and a wooden building that housed the telephone company on the second floor and a tailor on the first floor.

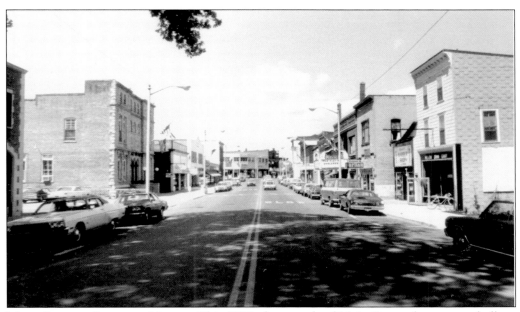

MAIN STREET, LOOKING NORTH. This 1977 photograph of Main Street shows town hall on the left and stores on the right. These stores included a barbershop, a theater, a restaurant, a fruit market, and a drugstore. The streetlights have changed considerably from a light bulb on a wire to a more attractive and welcoming sight. Currently, the lights have been replaced again with retro-looking gaslights.

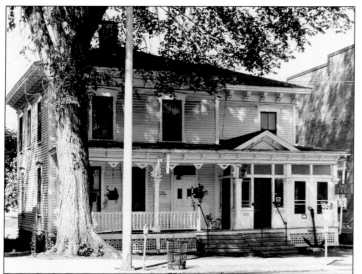

THE MASSENA MUSEUM. Until 1980, the Massena Museum was located in the basement of town hall on Main Street, where conditions were crowded. In 1981, the town purchased a new building (a former wing from the barracks hospital) and a lot at 200 East Orvis Street to become the museum's new home. In 1995, a large addition was built to incorporate the Aluminum Association Museum. Together, the two tell the story of Massena's history.

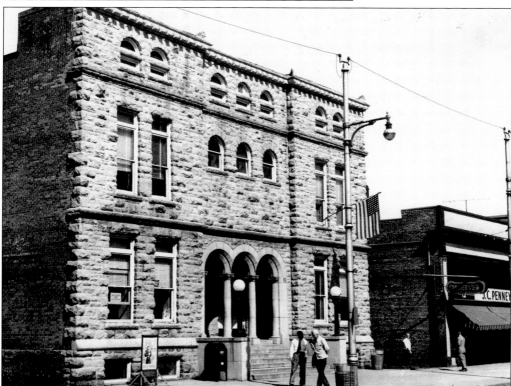

THE MASSENA TOWN HALL. The first Massena town hall was a brick structure erected in 1856 on the site of the present building and served the township as a meeting place from 1903 to 1904. Prior to that, town meetings were held in the home of the town supervisor or at local churches Along with the post office, town library, and meeting rooms on the first floor, there was an opera house that seated 425 people. On the second floor were a gallery that seated another 200 people and a large room for town meetings. In the basement was the police station.

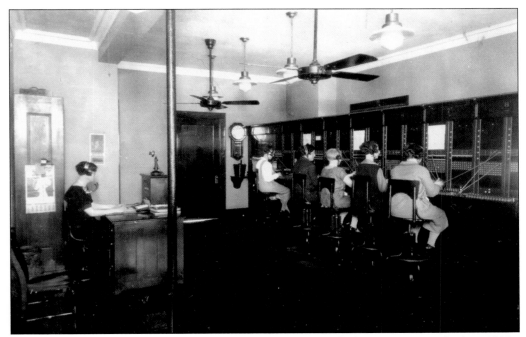

THE TELEPHONE COMPANY. The first telephones were installed in Massena in the late 1890s, shortly after the power canal was constructed. As early as 1888, there were several private telephone lines in Massena. The first full-time operators were Nellie and Genevieve Colgooun and Violet Carney. The three operators worked 15 hours a day and earned $20.00 per week. Eventually 45 operators handled approximately 17,000 calls a day.

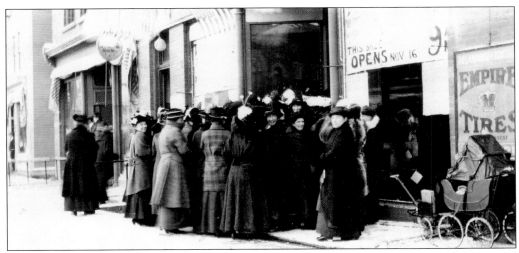

THE CUBLEY STORE SALE. On November 16, 1909, Massena women were crowding around the Cubley Store to shop for big bargains in furniture, rugs, and bedding. The announcement on the right window says, "We quit business and will sell our stock worth $10,000 at genuine closeout prices." Later on, this site was occupied by the National Army Store.

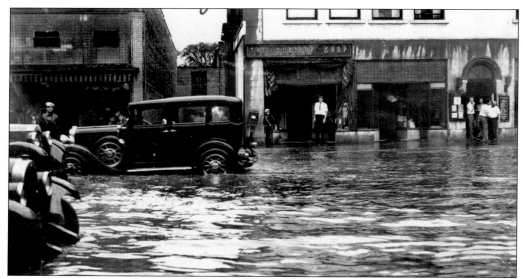

THE 1931 FLOOD. The Great Lakes River basin, as well as the St. Lawrence River Basin, produced tremendous quantities of water during the yearly spring melt. With most of the Great Lakes' runoff draining through the St. Lawrence River, flooding of shoreline communities was a common occurrence. Here we see Main Street, Massena, in the midst of the 1931 flood.

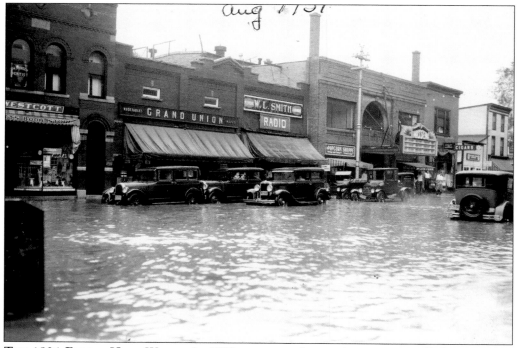

THE 1931 FLOOD, HIGH WATER. In 1903, a system of storm drains was installed to provide a way for the flood waters to drain away from the village. Vehicles of the day sat fairly high off the ground and thus were able to drive through all but the deepest of water.

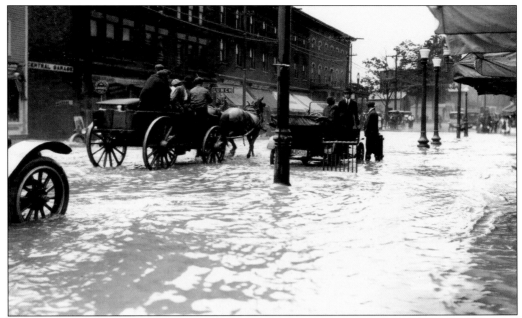

THE FLOOD, JULY 29, 1931. Despite flood waters, life goes on and people try to go about their daily business. Horse-drawn wagons were still quite common to the area, and horses had little or no problem pulling wagons through the water. Needless to say, there was considerable damage caused by the flooding conditions. Basements were flooded and many factories had to shut down until water levels fell.

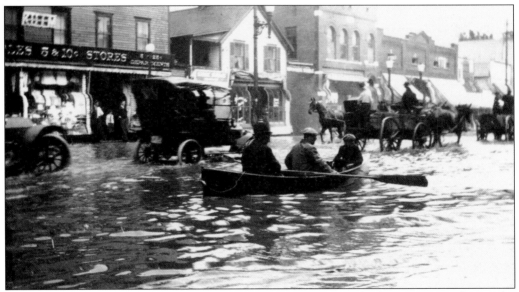

THE 1931 FLOOD, DOWNTOWN MASSENA. When people have little or no control over the elements, they are left with no alternative but to adapt to the prevailing conditions. Here, we see some resourceful citizens using a boat to get around on Main Street. It was reported in one newspaper that a department store clerk stuck a fishing pole out his office window, and using a piece of cheese for bait, caught a large fish that he took home for his supper.

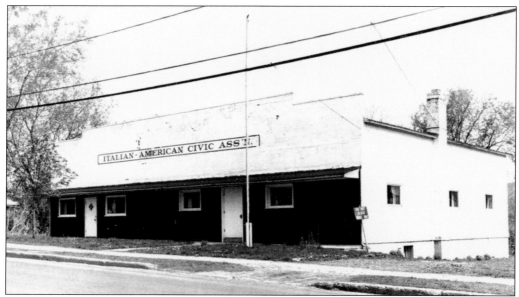

THE ITALIAN-AMERICAN CLUB. During the construction of the canal, Massena became a melting pot of nationalities; yet the immigrants maintained their identities through church and social activities. The Italian-American Club was established to offer a gathering place for Italian immigrants. The Sons of Italy began in 1917, and the building was constructed and opened for use in 1930. The name was changed in 1960 to the Italian-American Civic Association.

THE AMERICAN LEGION. The American Legion Post 79 was formed in 1919. The Legion purchased the 1829 building on East Orvis Street in 1944 and built an addition in 1994. Members of the American Legion Auxiliary spend their time doing rehabilitation work with disabled veterans and supporting civic projects. In 1969, Post 79 celebrated its 50th anniversary. The American Legion received a long-awaited military aircraft: a 1966 medical helicopter used in Vietnam. It is on display in front of the American Legion.

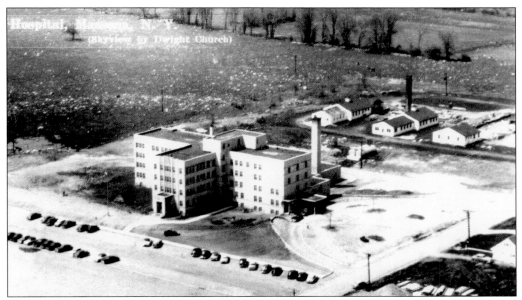

Hospital, Massena, N. Y.
(Skyview by Dwight Church)

THE MASSENA MEMORIAL HOSPITAL. Before 1944, there were two private maternity homes and a private hospital. Dr. Rollin Newton and his wife donated the land for a public hospital on Maple Street. Initially, military barracks–type structures (right background) were used to house Massena Memorial Hospital near the Maple Street site. Construction of the current hospital (foreground) began in 1950 and the facility opened in October 1952.

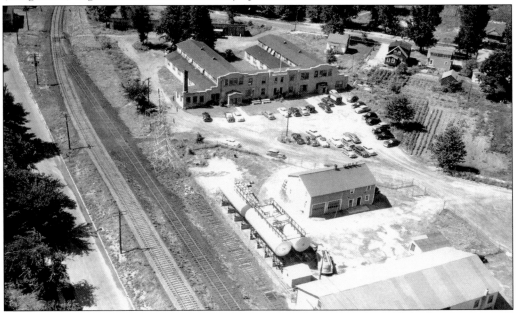

THE SILK MILL. In 1919 the Cedar Cliff Silk Company mill was established in Massena. It meant jobs for women at a time when the only work acceptable was housework. Massena was a one-industry town; the Aluminum Company of America was man's work. When the Depression hit, the silk mill was closed down. Eventually, the old building was purchased in the 1970s and used as a warehouse.

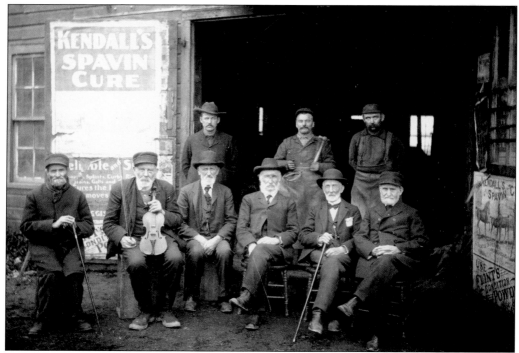

THE BLACKSMITH SHOP, MAIN STREET, 1905. The men pictured here are, from left to right, as follows: (seated) William Wright, Harvey Russell, Myron Southwick, Horatio Clark, Joseph Clary, and Luke Dana; (standing) Steve Daley, James Lloyd, and John Davis. The blacksmith shop was torn down in 1936 to provide a site for the new post office.

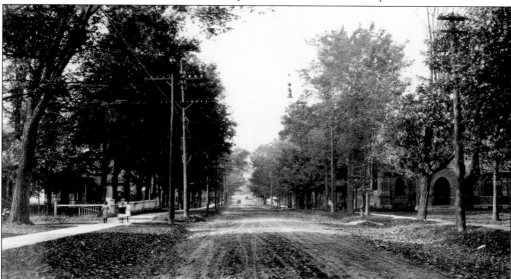

MAIN STREET. This is Main Street in the early 1900s. St. John's Episcopal Church is on right. Notice all the beautiful trees surrounding the church and lining Main Street. There are three small girls walking on the sidewalk on the left. In the center of the photograph is a light hanging down by a wire that was used for lighting before modern streetlights were installed.

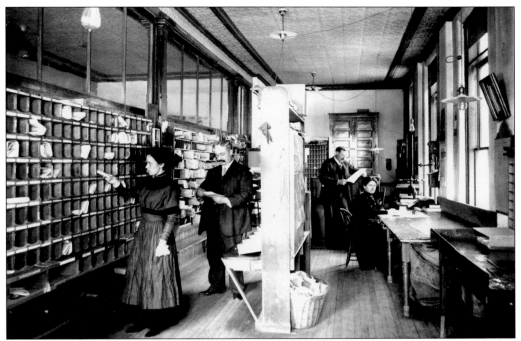

THE OLD MASSENA POST OFFICE, 1904. One of the locations for the post office was in the town hall on Main Street. The post office later moved to the site formerly occupied by a blacksmith shop.

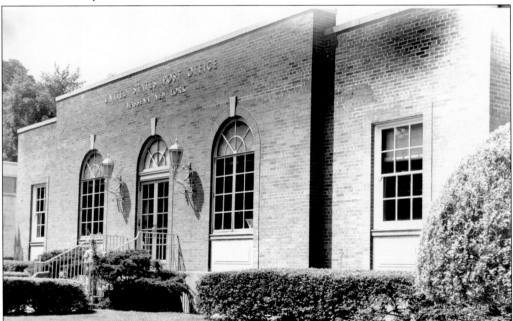

THE POST OFFICE. The present post office was built on Main Street in 1936. Prior to that, the federal government leased space in private buildings around town, beginning in September 1918. The town's first postmaster was Orick Hosmer.

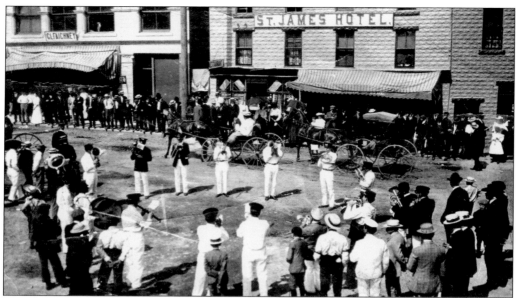

THE ST. JAMES HOTEL. The St. James Hotel catered to the workingman. It was built on the west side of Main Street in 1899 by George E. Martin, during the canal construction days. Ignace Plumadire of Cornwall, Ontario, was the first proprietor, followed by Paul Lacrosse in 1903, Guy Bridges, and then Robert Wilson in 1915, who owned it until Prohibition in 1918. The hotel then became Louise A. Keenan's boardinghouse. The hotel burned down in 1921, and Clopman's Furniture and Appliance Store occupies the space now.

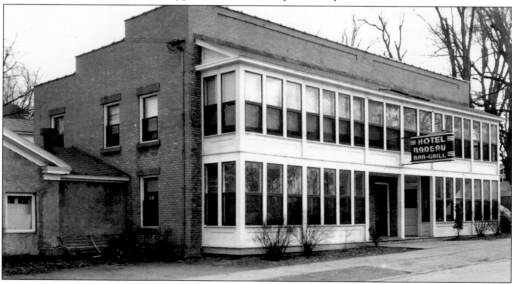

THE HOTEL NADEAU. The Hotel Nadeau is possibly the oldest business building in Massena. The low portion of Nadeau's Bar on Andrews Street once housed district No. 16 pupils. The school was built in 1837 by Martin P. Crowley for $272. It replaced the original school building, erected in 1803 on Water Street and used as a school until 1866. The school was disposed of by trustees and rented to various tenants for use as living quarters and small businesses until it was purchased by Nadeau, who turned it into a hotel and bar.

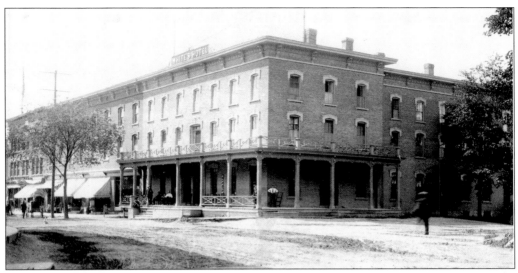

WHITE'S HOTEL. White's Hotel was built in 1864 on the corner of Main and Andrews Streets by H. B. White. In December 1933, Massena's largest fire occurred during a sleet storm and caused over $150,000 in damages. The hotel lobby, 49 bedrooms, the dining room, and other rooms and their contents were all destroyed, as were some Main Street stores and a barbershop.

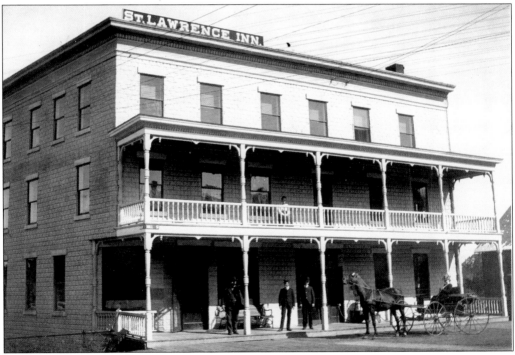

THE SAINT LAWRENCE INN. Following its early days as a carriage works and blacksmith shop, this building near the Grasse River Bridge was converted into a hotel in 1887 by Bill Williams. While the power canal was being built, many of the men working on the project called the St. Lawrence Inn their home. In 1922, the original building burned and was rebuilt by Slavin and Shulkin for a furniture store.

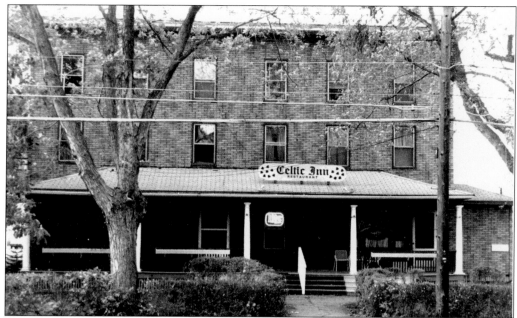

THE CELTIC INN, 40 WOODLAWN AVENUE. Steve Syakos purchased the property from Pine Grove Reality in 1913 and sold it to Joseph Romeo in 1920. Romeo's widow then sold the property in 1924 to Louis Tamer, who later sold it to Andrew Cecot Jr. and Felix Cecot, who formed the Woodlawn Hotel Corporation in 1946. In 1949, the Dzreioisz family first leased and then purchased the Woodlawn Hotel. In 1976, the hotel was sold to Patrick and Willa Murphy, and the name was changed to Murphy's Celtic Inn. The building was sold in 1998 to Scott Proper, who turned it into a three-story apartment house.

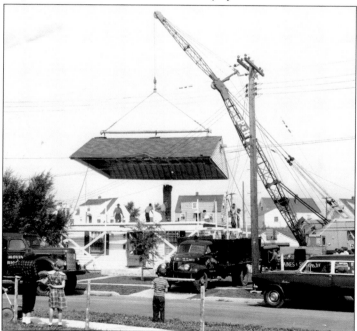

HOMECROFT HOMES. Massena had a critical shortage of housing when production increased during World War II and more people were employed. In 1941, the Homecroft Realty Company financed 300 units for $1.2 million. Six basic designs were built. Many of the homes were of modular construction and assembly was fast; many homes were built in a single day. Here we see the completed roof being lowered in place on one of the new homes.

Three

THE CHURCHES

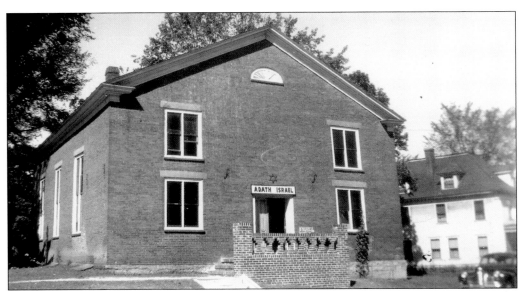

THE ADATH ISRAEL SYNAGOGUE. Emmanuel Congregational Church was located on the corner of West Orvis and Church Streets. This church was sold in 1919 to the Adath Israel Synagogue and moved there so the new Congregational church could be constructed. The new church building was completed in 1926.

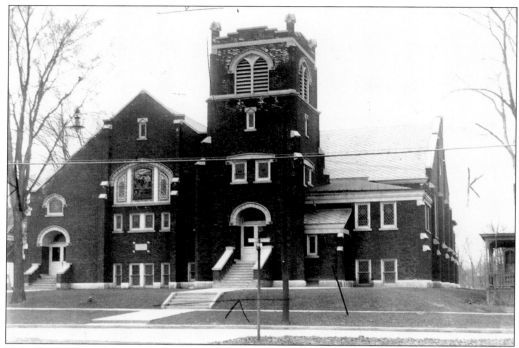

THE CONGREGATIONAL CHURCH. The First Congregational Church was established in 1806 at Massena Springs by Rev. Amos Pettengill. It was not until 1819 that the first church was actually organized. On July 31, 1833, the first services were held, and on September 4, 1833, the Second Congregational Church (pictured above) was formed in the village of Massena on West Orvis Street.

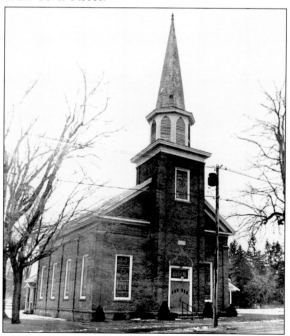

THE FIRST BAPTIST CHURCH. The Baptist church was founded in September 1843. Baptists were in Massena as early as 1825. In 1827, Col. D. H. Orvis built a frame house on West Orvis Street for religious meetings. The cornerstone was laid in June and the first services were held in 1860. The red bricks for the walls were made in Raymondville, transported down the Racquette River to Massena, and brought to the site by oxen-drawn wagons.

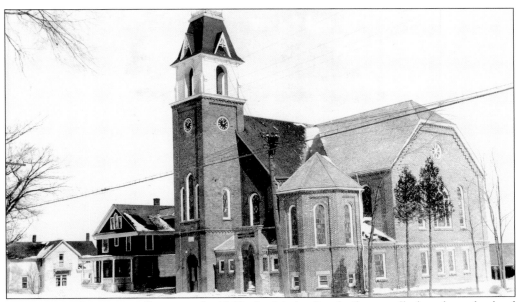

THE FIRST METHODIST CHURCH. In 1848, the Methodists built a small chapel on the land where St. John's Episcopal Church currently stands. In 1868, the decision was made to build a church. The cornerstone for a new church was laid in 1868, and the building was dedicated in September 1870. In 1875, the stained-glass windows by Hauser Studios were completed. A new steeple that weighed 35,000 pounds was installed in February 1896.

THE NORTH SIDE COMMUNITY ADVENT CHRISTIAN CHURCH. The Advent Christian Church began in Massena Center. Land was purchased on North Main Street and construction started in 1872. The church was completed in 1874. The interior has been remodeled, including new flooring, electric lights, and an addition for Sunday school. Stained-glass windows and a modern baptistery have been installed. An education unit was added in 1974. "North Side Community" was added to the name in the 1980s.

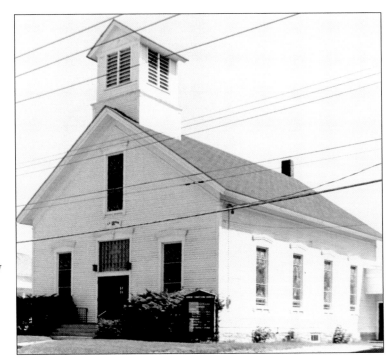

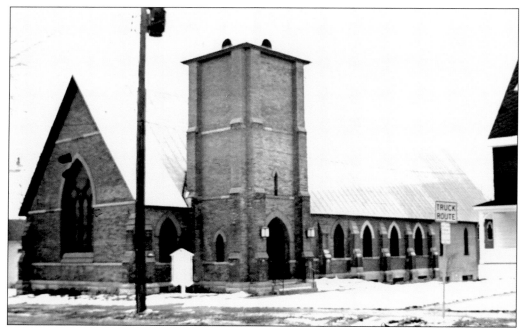

ST. JOHN'S EPISCOPAL CHURCH, 139 MAIN STREET. Services were held in various places in Massena before the parish was organized. The Episcopal congregation's regular services were started in 1869 under the name Good Shepherd, but the name was changed to St. John's in 1871. The small chapel, which was built by the Methodists, was used until the present church was erected in 1885. The church was enlarged between 1957 and 1958. At one time, the church had missions on Barnhart Island and Louisville Landing.

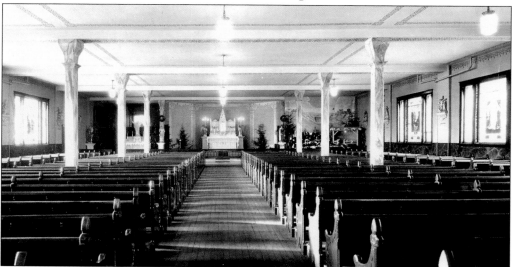

ST. MARY'S CHURCH AND SCHOOL. Groundbreaking ceremonies for the new church on the site of the old rectory took place in May 1954. The church was completed in May 1956. In 1923, the parochial school of St. Mary's was opened in three rooms. Every year after that a new classroom was added. In 1940, a new school building was erected on Cornell Avenue. It was called the Little School because it was used for little children in first grade and second grade.

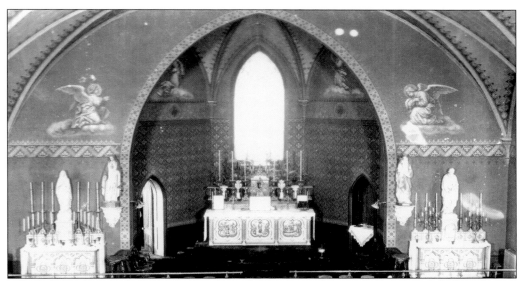

THE SACRED HEART CHURCH. The Sacred Heart Church on Main Street was built in 1924 after the Massena Springs activity ceased and the old church site was no longer the center of the population. The old church was used as a parish hall after the new church was ready. Property nearer to the village was purchased and the foundation was laid in 1922. The first Mass was celebrated on Christmas Day 1924. The church could seat 800 people, and was erected at a cost of $250,000. Later, a school, a rectory, and a convent were all erected to complete the church and its services.

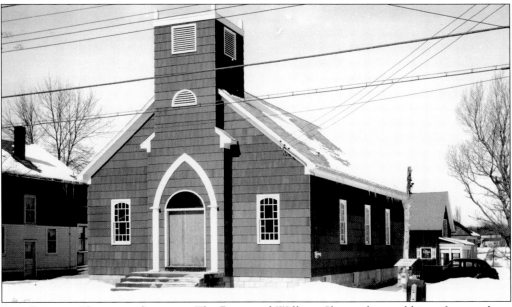

THE PILGRIM HOLINESS CHURCH. The Reverend William Shoemaker and his wife came here as home missionary preachers. The first service was held in the Union Church in Massena Center. In 1941, the Pilgrim Holiness Church was incorporated. In 1953, a lot was purchased and the new church was built at 226 East Orvis Street. In August 1989, the church was moved from East Orvis Street to its present site on Route 37 West.

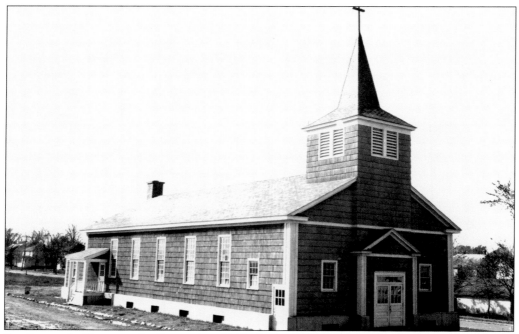

ST. JOSEPH'S CHURCH. In September 1947, St. Joseph's became the third Catholic church in Massena, located on the corner of Malby Avenue and Bailey Road. The Aluminum Company of Massena had donated the lot for a new church. Originally the church building was a World War I army chapel at Camp Shanke, Long Island. That chapel was dismantled and shipped by truck to Massena. Ground was broken in May 1948, and the first Mass was celebrated on Christmas Eve 1948. In 1958, construction of a new St. Joseph's school began, and it was dedicated in 1959.

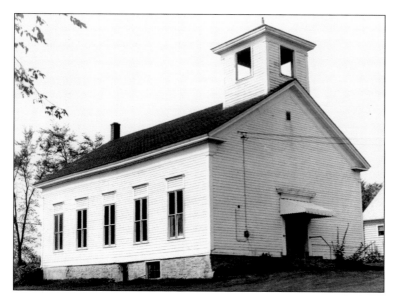

THE RACKET RIVER CHURCH. This church was built in 1856. The parent churches were the Racket River Church and the Massena Center Methodist Church, which were served by one pastor in 1904 and eventually merged in 1961. A new church was built on Route 37 in 1964 to replace this one. It is now known as Grace United Methodist Church.

Four

THE SCHOOLS

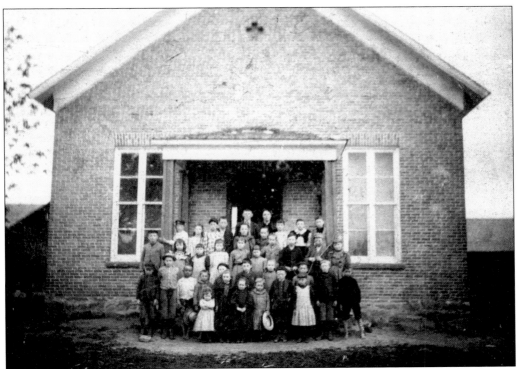

ONE-ROOM SCHOOLHOUSE AND STUDENTS. In 1815, Massena received $9.46 in state funds to build a schoolhouse. It was located on Water Street and served the village until 1837, when a new brick schoolhouse was built for $275 near where Nadeau's Bar is currently located. Also, frame schoolhouses were built on Center and North Main Streets. The teacher's salary was $4.50 to $6 per week, plus $2 for room and board per week. The teacher's tasks included filling lamps, cleaning chimneys, trimming wicks, and bringing in a bucket of water and coal daily. Teachers who married were discharged. In 1894, teachers were paid at the end of the month instead of the end of the week.

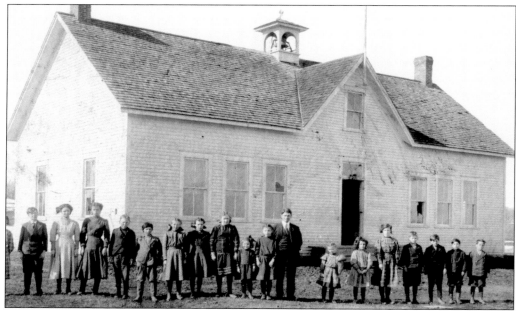

THE RACKET RIVER SCHOOL. The Racket River School was located in District No. 3 from 1813 to 1826. A report in 1814 noted 25 children in attendance; 27 were enrolled at the time of the next report in 1818. In 1826, the people on the south side of the Racket River petitioned to have the district divided because they felt their children had to walk too far to get to school. Another schoolhouse was then built at Minkler's Corner, and it later was moved to Cotter Crossroads.

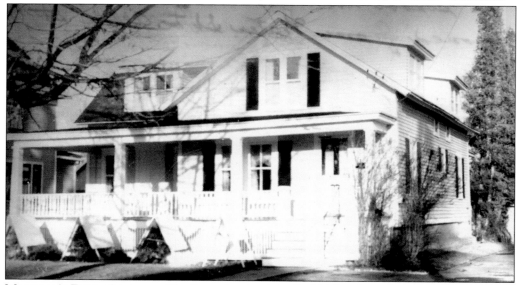

MASSENA'S EARLY SCHOOLS. The first school, originally 151 feet from the corner of Water and East Orvis Streets, was moved to West Orvis Street, where the Congregational church is now. It was open from 1803 until 1814, when a state law was passed to regulate the maintenance of common schools. The first teacher was Gilbert Reed. The school is now part of a house on Allen Street, where it was moved in 1920. In 2003, the original historical marker was reinstalled at the corner of Water and East Orvis Streets.

THE OLD MAIN STREET SCHOOL. The three-story brick structure on Main Street was erected in 1868 at the cost of $14,000. It became known as the Old Main Street School. In 1899, an addition was built on the building's north side. It continued to house the high school until 1918, when all students in grades 7 through 12 were moved to the new Bridges Avenue School, and the Old Main Street School became a grammar school. In 1926, the name was changed to Harrowgate School. On November 11, 1926, fire destroyed the building.

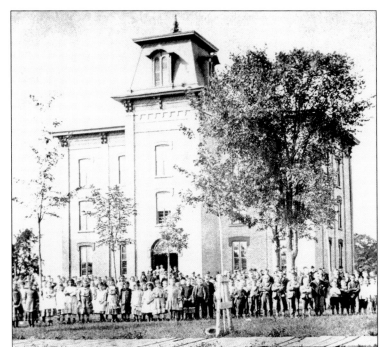

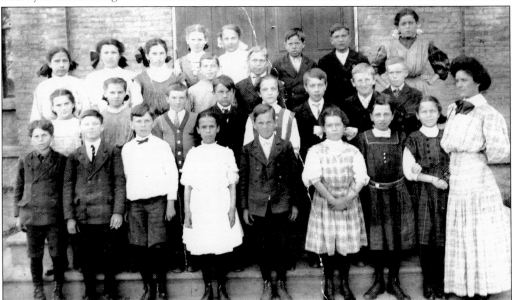

HARROWGATE SCHOOL CLASS PICTURE, 1907. From left to right are the following: (first row) Erden Sharlow, Leonard Grow, George Wilson, Sarah Carney, Alfred Fetterly, Ruth Leonard, Julia Bero, Mildred Fletcher, and teacher Mary Sullivan; (second row) Bertha Hoadley, Amy McClifmont, Frank Morrill, Everet Gibson, Geneva Perry, Carl Sprague, Daniel Holiday, and Ansel Bailey; (third row) Julia Besaw, Florence Dow, Pauline Morrill, Clarence Lockwood, and Duncan McDonald; (fourth row) Ethel Gray, Myrtle Day, Ben Locke, George Jenkins, and Rose Prashaw.

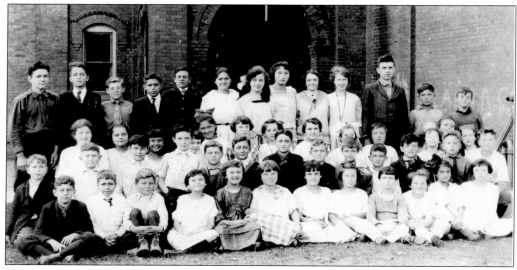

HARROWGATE SCHOOL, 1923, GRADE 5A AND 5B. From left to right are the following: (first row) Floyd Murray, unidentified, Lawrence Ashley, Dorothy Shulkin, Cecile Clough, Violet Sherwood, Jean Alguire, Irene Chase, two unidentified students, Catherine Romeo, and unidentified; (second row) Millard Gary, unidentified, James Bourdon, Wallace Danforth, Cutler Warren, Charles La Tray, unidentified, David Reed, Robert Parsons, unidentified, Richard Brown, Floyd Ramsey, and Floyd Touchs; (third row) Georgianna Evans, Monica Beaulieu, Ida Mae LaShomb, Mary McHugh, Catherine Currier, Angela DeGrossillier, Dorothy Gardener, Cathy Cardinal, June Shampine, Jean Sommers, Viola Snyder, ? McDonald, and Grace LeClair; (fourth row) Noah Revote, Wilton Whitten, James Rosa, Walter Beaulieu, Eli Santandress, Dorothy Currier, Millie Evans, Cora Mayville, teacher Ethel Tyon, Clara Sanell, William Runions, and two unidentified students.

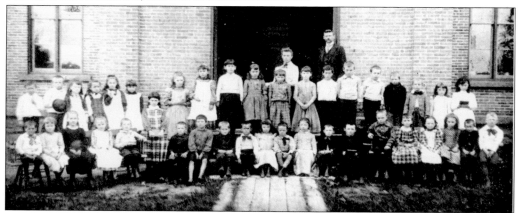

HARROWGATE SCHOOL CLASS PHOTOGRAPH. From left to right are the following: (first row) ? Revier, Lou Hyde, Florence Mordeu, Ethel Grant, Fred McGuinn, Clara Hudson, Sidney Dodge, Clifford Shambo, unidentified, Harold Mordeu, unidentified, Guy Anderson, Grace Minkler, Fred Kirkbride, unidentified, John Russell, Nellie Cline, unidentified, Jessie McGuinn, Ira Porter, and Cecil Flemming; (second row) two unidentified students, Jessie Power, Vicky La Barge, Nancy Smith, Annie Nelson, Jessie Sutton, Minnie Spooner, Edith McClellan, Ethel Bayley, unidentified, Stella Wilson, unidentified, Homer Hamilton, Callie Wilson, Charlie Cline, Max Mebb, ? Wilson, and Annie Finnegan. The two people in the back row are unidentified.

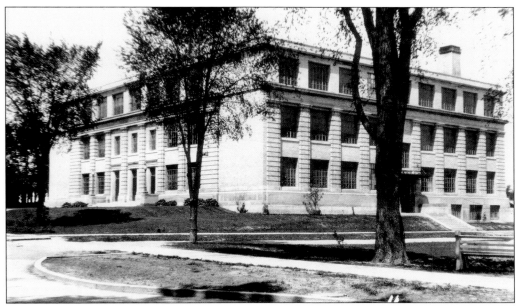

THE MASSENA CENTRAL HIGH SCHOOL. This school was built in 1953. Massena Central High School used a six-track system: regents, accelerates, enriched and school credit, limited learners, and educationally retarded. Students were sorted into two groups: school credit or non college bound, and regents credit or college bound. In Massena High School, one-third of the students are designated as school credit, and two-thirds are regents credit. The high school did offer courses in business, college preparatory and general subjects, homemaking, industrial arts, and art.

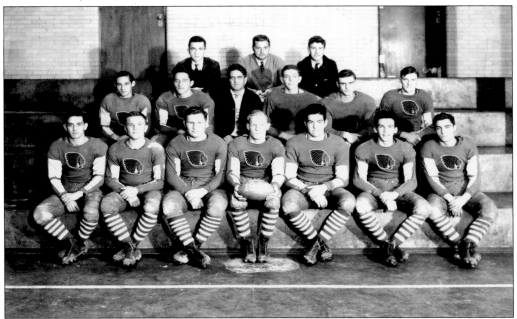

THE MASSENA HIGH SCHOOL FOOTBALL TEAM, 1936. Pictured are members of the first team for Massena High School in 1936. The school also fielded a second team in football.

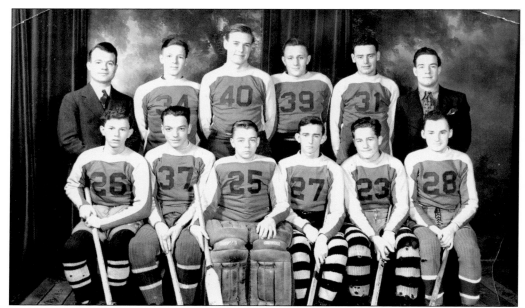

MASSENA HIGH SCHOOL'S FIRST HOCKEY TEAM, 1938. From left to right are the following: (first row) R. Sharlow, G. Markell, J. Sullivan, C. Miller, L. Parisian, and I. Silmser; (second row) coach E. R. Hughes, H. Ure, James Taylor, Robert Amo, Ken Kirkey, and assistant coach Louis Hiter. Not pictured is assistant coach J. Lahey.

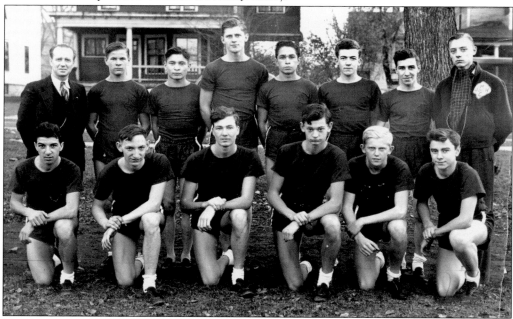

THE MASSENA HIGH SCHOOL CROSS COUNTRY TEAM, 1937. Lettermen members of the 1937 cross country team are pictured. From left to right are the following: (first row) Garth Avery, Solomon Cook, Steve Dziewisz, Harry Fregoe, Kenneth Sharlow, and William Terrance; (second row) coach Henry White, Arthur Tupper, Frederick Geneway, Vincent Hutt, Howard Marsh, Roy Germano, Edward Kochienski, and team captain William Terrance.

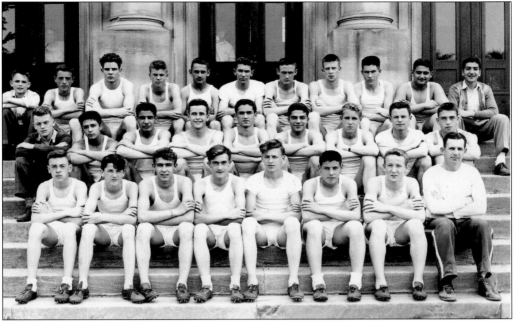

THE 1945 MASSENA HIGH SCHOOL TRACK TEAM. Although not identified in order, the team members pictured here include D. McDonald, T. Hartford, P. Smith, W. Smith, Kenneth Prosper, V. Gillespie, manager J. Cutry, V. Baratian, J. Evans, G. Granger, H. Bogosian, W. Ayers, V. Hamke, A. Boisvert, N. Godfrey, manager C. Sharlow, W. Lewis, V. Kulbach, J. Krywanczyk, A. Bourdon, Keith Prosper, W. Hatch, D. Cutler, A. Almasian, E. Kassian, manager R. Fralick, J. Moroney, B. Bach, and M. Krywanczyk.

THE LINCOLN SCHOOL. The people of Massena voted on April 13, 1925, to erect the Washington and Lincoln Schools. A lot on Beach Street was picked for the Washington School, and a Brighton Street site was picked for the Lincoln School. The schools accommodated the students close to their homes. The neighborhood school was quite popular for the parents of small children.

THE WASHINGTON SCHOOL, BEACH STREET. The burning of the Main Street School in 1926 made it necessary to complete the construction of the two grammar schools as quickly as possible. Washington School opened in January 1927. The brick school served 400 children, ranging from kindergarten through sixth grade. The building was sold in 1977 and was razed in November 1981.

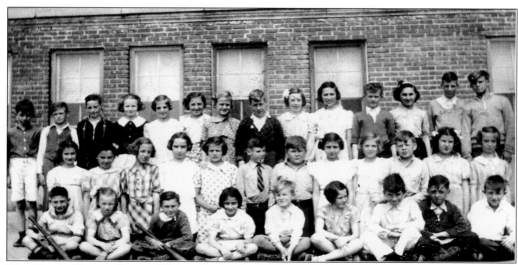

THE FIFTH-GRADE CLASS, WASHINGTON SCHOOL, 1936. From left to right are the following: (first row) Albert Tricase, Joyce Matice, Howard Losey, Betty Pellegrino, Leo Martin, Jean LaGrove, Norman Littlejohn, Tony Savoca, and Duane Robinson; (second row) Jean Pellegrino, Doris Rosoff, Marjory Rollins, Diana Southworth, Helen Yukno, Richard Peer, Lee Robinson, Carmel Pellegrino, Adela Gill, Donald Kennedy, and Kitty Ryan; (third row) Eugene Perry, Joe Romankiewescz, Ralph Miller, Shirley Patterson, Loretta LaDue, Pauline Savoca, Erwin Parisian, Norma Marky, Muriel Welcher, Raymond Kocienski, Angela Savoca, William LaDue, and Pierre Tessier.

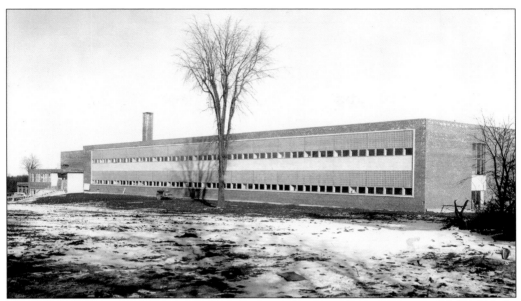

THE JEFFERSON SCHOOL. In 1954, the Jefferson School was built at a cost of $456,000. In November 1955, the voters approved a $338,000 addition to the school, which was only a year old at that time. The addition included 10 classrooms and a cafeteria. Not long after that, it was necessary to vote on a bond issue of $9.2 million. It was approved, and construction was started in 1957 for four elementary schools and a new high school.

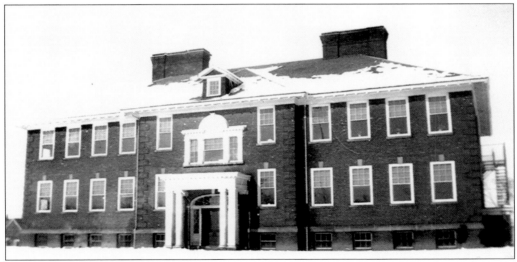

THE PINE GROVE SCHOOL. The population in Massena increased considerably in the early years of the power canal construction project. The board decided to build an additional school in the Pine Grove section. Work was started in 1907 and was completed in April 1908. Night school classes were started at Alcoa and they were moved to Pine Grove School. Teachers taught English and U.S. history classes to the immigrants for naturalization.

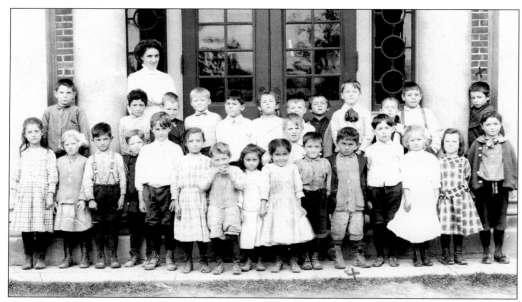

THE FIRST-GRADE CLASS, PINE GROVE SCHOOL, 1913–1914. From left to right are the following: (first row) Bernice Carbino, Dorothy Locke, Frank Vari, Harold Malone, Miles Greene, Mary Bronchetti, Ray Malone, Mary Trimboli, Frances Germano, Frank Bronchetti, Alexander Scibo, Leon Carbino, Lizzie Toth, Elizabeth Guindon Yaddow, and Ralph Hough; (second row) Kenneth Squires, Joe Spadafore, William Humphrey, Gordon Noonaw, Fred Blair, Henry Alguire, Arthur O'Neil, Simon Levine, Aubrose Fitzpatrick, Martha Runions, Charlie Dueor, and Dominick Givannoni. The teacher at the back is unidentified.

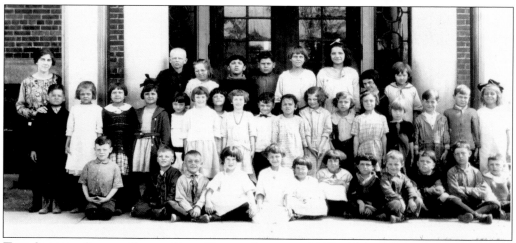

THE SECOND-GRADE CLASS, PINE GROVE SCHOOL, 1925. Although not all of the class members are identified, the students pictured here include G. Martine, Mary D' Arenzo, ? Romeo, Sam Catanzarite, Agnes Lahey Sharp, Beatrice Bartholomew, Ruth Sweeney, Isabel Brennan, Dave Molnar, Bill Leafe, Geneva Yuckno Molnar, Carol Leafe, Pearl Keerd, John Baysuk, Bernard O'Neil, Ruth Boyce Hagen, Margaret Germano Portolese, Betty Catanzarite, Veronica Jacobs, Helen Proszi Jukoski, Bob Hutchins, Buck Bourdeau, Joe Balazs, Beatrice Olmstead Perri, Carol Miller, Arnold Fetterly, and R. Faucher. Mae Richmire is the teacher shown in this image.

THE HOLY FAMILY CATHOLIC HIGH SCHOOL. The Rt. Rev. Msgr. Louis Berube, vicar-general of the Ogdensburg diocese and pastor of Sacred Heart Church, broke ground for Holy Family Catholic High School at 3:30 p.m., April 21, 1960, on the lot between Ransom and Highland Avenues. Despite fund-raising efforts, Holy Family became too expensive to keep open and was closed in 1975. However, it was reopened in 1981 as Massena's new junior high school.

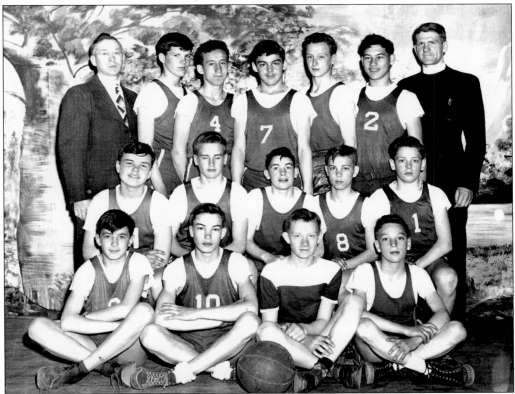

THE TRAVELING BASKETBALL TEAM, SACRED HEART SCHOOL, 1947–1948 SEASON. From left to right are the following: (first row) Jack Diagostino, Russell Patnode, Lawrence Prashaw, and Donald Grow; (second row) Robert Leroux, Paul King, William Hurley, Willie Deshaies, and Robert LaBaff; (third row) coach Creed DeParis, Clifford Anable, Allen Rushlow, Patrick LaClair, Florient Morin, John Belanger, and Fr. Michael Jarecki of Sacred Heart Parish Church.

THE BRIDGES AVENUE SCHOOL. In order to provide school accommodations for the children on the south side of the village, the new Bridges Avenue School was built. It opened in 1916. In 1926, the school was enlarged and became Massena High School. In 1956, the school operated on half-day sessions because of the large number of families that moved to Massena to work on the construction of the seaway.

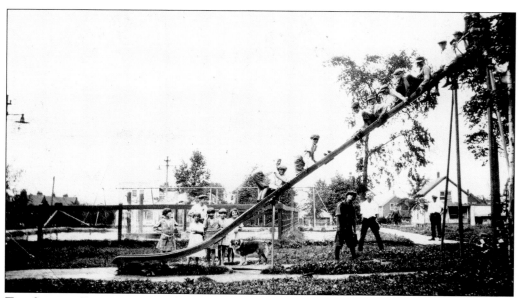

THE SCHOOL PLAYGROUND. Alcoa built many low-cost, affordable homes for their employees, as well as recreation areas. This playground was built for the use of the children of Alcoa employees. It had a swimming pool, several swings, and a slide large enough to thrill any child. (Courtesy of Mike Francia.)

Five

THE HOMES

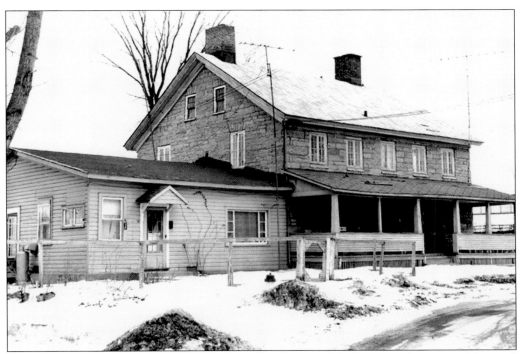

THE HASKELL HOUSE. The stone marker entitled "Site of the First Settlement in Massena" once sat at the corner of East Orvis and Tamarack Streets. The settlement began in 1792 with the creation of a sawmill. The site is now occupied by a stone house built by Capt. Abel Haskell in 1826. It was a large, two-story, oblong house with a big door in the center. The property remained in the Haskell family until it was sold to Alcoa to house workmen c. 1915.

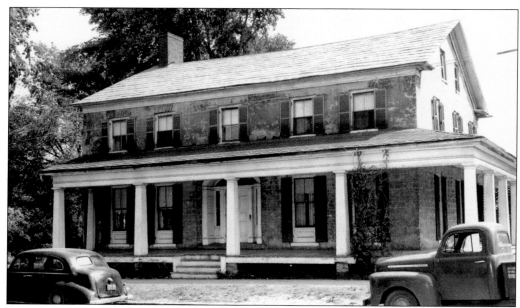

THE PHILLIPS HOUSE. Six generations of the Phillips family lived in the house located at 16 Phillips Street. The house was built in 1831 by Benjamin Phillips. The Phillips family came from England and settled in Canada before arriving Massena in 1817. Benjamin bought land in Massena and started a very profitable lumber business. In 1848 he began to make commercial use of the spring water from the Racquette River. The house was taken down in August 1988.

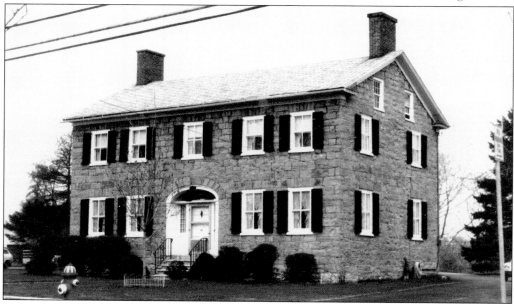

AN ANDREWS STREET HOUSE. One of the most beautiful houses in the North Country is the Georgian Colonial at 80 Andrews Street, built of native limestone and currently occupied by the mayor of Massena. In 1810, John B. Andrews came to Massena. He became the supervisor of Massena for several terms and was one of the town's early postmasters. The home was constructed c. 1833 of stone quarried from the bed of the Grasse River.

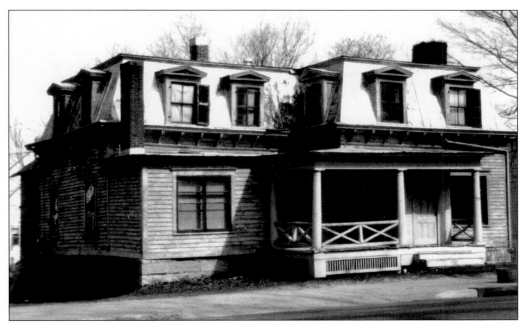

THE SQUIRE BEACH HOUSE. The home was built and designed by Squire Beach in 1840 on land he had purchased in the business section in 1838. The home is constructed of stone, brick, and Russian iron. The foundation of the home is made of stone quarried from the bed of the Grasse River and laid in mortar made from a lime kiln nearby. The inside walls of the home are lined with brick, and the mansard second story is made of Russian iron.

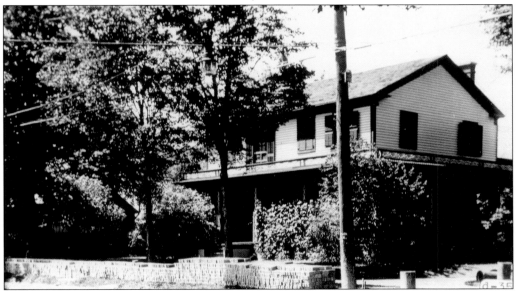

THE WARREN HOUSE. Henry Warren came to Massena in the 1870s and built his family home on the corner of Main Street and West Orvis Street. He was an engineer and recognized the possibility of water power in Massena. Warren was instrumental in developing the power canal. He also purchased large areas of land in and near the village of Massena. Henry Warren served the town of Massena as mayor from 1893 to 1904. The public library is named after him.

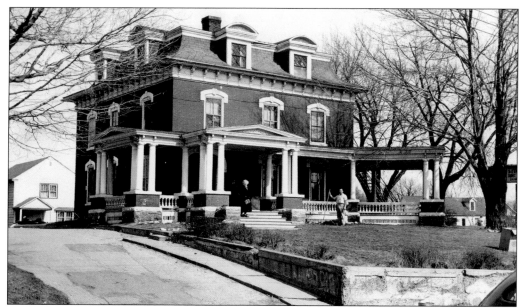

THE HORTON HOUSE, NORTH MAIN STREET. William Goodrich built this three-story brick house in 1874. After he died, the house was rented for a few years, and after several owners, Elon A. Horton, who had a carriage business, bought it. In 1940, the property was leased to Dr. L. J. Calli, who established a private hospital. The state acquired the land in 1957, and the house was razed to create a highway between Maple and Center Streets.

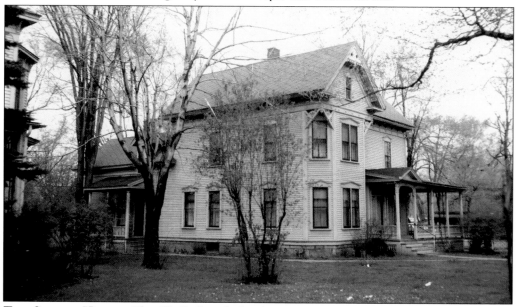

THE SNAITH HOUSE. The W. S. Snaith family came to Massena from Montreal in 1866. Snaith operated a tin shop and hardware store for many years. The Snaith House, located at 14 East Orvis Street, on the corner of Glen Street, was built in 1873. This served as the home of the Snaith family until the property was sold in 1940, and a Texaco gas station was erected on the land. The house was moved to the back of the lot to face Glen Street.

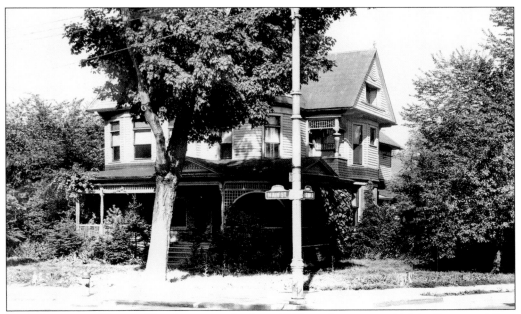

THE KIRKBRIDE HOUSE. This house was built in 1893 on the corner of Main Street and East Orvis Street. It was made of brick on the lower half and clapboard on the upper half. Frederick Kirkbride was in the dry goods business, which was located on the block he had developed. In 1954 the Kirkbride property was sold to the W. T. Grant Company, which demolished the house and built a store in its place.

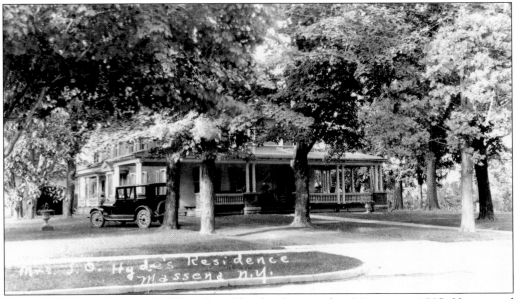

THE G. W. BALL HOUSE. G. W. Ball and his family moved to Massena in 1885. He married the stepdaughter of Judson Hyde in 1891 at the home of the bride's parents, at 159 Main Street. Ball purchased his stepfather's department store in 1902 and later sold it to Isaac Friedman. It then became the Stone and Company Store. In 1906, G. W. Ball purchased a coal business on Water Street. In 1916, his son-in-law Allan P. Sill joined in the business.

THE DUTTON HOUSE, WEST ORVIS STREET. This house was in the Ransom family for nearly a century. During the Civil War, the home was known to have housed soldiers. After Henry Ransom died in 1897, the property passed to his widow, Almira Ransom. She died in 1902, and the property then passed to Fannie Ransom, who married Alfred Dutton. Dutton died in 1938, and his daughter Jessie sold the house to the Schines Hotel Enterprises in the 1950s.

THE JOSEPH CLARK HOME, CORNER OF ANDREWS AND MAIN STREET. The Horatio Clark House once stood at the northwest corner of Main and Andrews Streets. It was built by Joseph H. Clark, who came to Massena from Vermont in 1820 with his wife, Mare Waite Clark. The home was passed down through the family until 1916. Eventually the house was moved to a location at 173–175 Allen Street. The Central Building occupied the corner lot after the house was relocated.

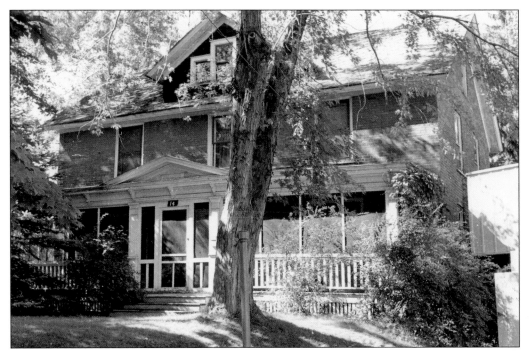

THE DEROSIA (HODSKIN) HOUSE. The Derosia House was located on the corner of North Main and Maple Streets. The large house was erected in 1875 by Capt. John Fox, a noted contractor of that time, who built the residence for Ira Hodskin. The Hodskin home was one of the finest that Captain Fox ever erected in the village. The house was later sold, and it passed through a number of hands before Franklin Derosia purchased it.

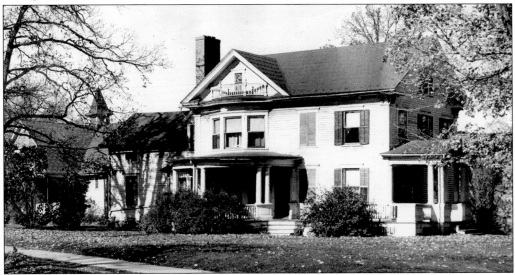

THE CLARK HOUSE. This is the Henry P. Clark property, located on the corner of Main Street and East Orvis Street. The Clark family owned the house for nearly 100 years. The Clarks also ran a local hardware business. The property was sold in 1947, and the new Schines Enterprise was erected in its place. Now it is a hotel.

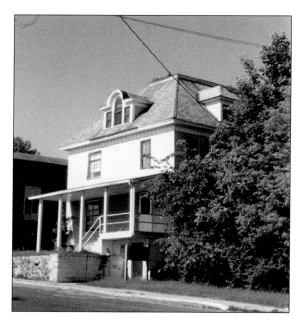

THE CARTON HOUSE. This large house, located at 14 Church Street, was built for Mary Allen Carton, a dressmaker in Massena for many years. Mrs. Carton went into the dressmaking business following her husband's death. She trained a large force of girls, and conducted business over the J. L. Hyde store on Main Street. Around 1907, she built this three-story home.

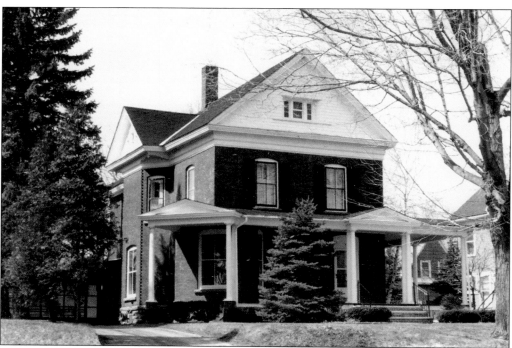

THE ALBERT P. BERO HOUSE. This Queen Anne house at 4 Elm Circle belonged to Albert P. Bero, who had it built between 1901 and 1904. He also purchased a building from L. S. Derosia and began to operate a dry goods and women's furnishing store. The house and lot eventually were donated to Sacred Heart Church and were purchased by Dr. Emmitt and his wife, Rosemary Folgert. Dr. Folgert was a prominent dentist in Massena, and he was instrumental in having fluoride added to the town's drinking water.

Six

THE PEOPLE

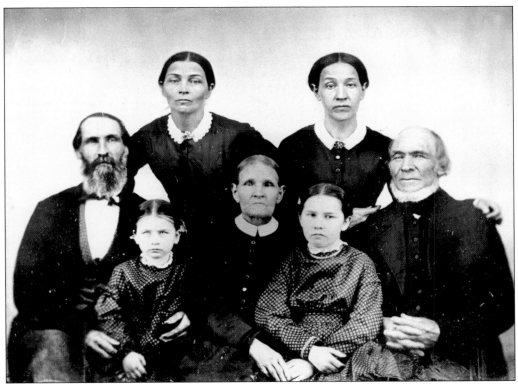

THE PAINE FAMILY. Pictured here are three generations of the Paine family, early Massena settlers. Seated from left to right are Joseph B. Paine, Grace Paine, Mrs. Joseph Paine, Alice Paine, and Joseph Paine. Standing behind them are Mrs. Joseph B. Paine (left) and L. Augusta Paine. The Paines were descendants of Robert Treat Paine, one of the signers of the Declaration of Independence. Grace Paine Richards was the last surviving member of the Paine family.

DANIEL DUNCAN ROBINSON (1774–1855). Born on November 19, 1774, Daniel Robinson moved with his family to Shrewsbury, Vermont, when he was four. An early pioneer, he went westward from Lake Champlain to St. Regis, crossed the St. Lawrence to Cornwall with two Indian guides, continued on to Ogdensburg, and then went downriver to Robinson's Bay. He purchased the land, cleared two acres, and planted wheat and corn. He returned to Vermont, and later came back to New York with his wife, Esther Kilburn, whom he had wed in February 1804. With the couple came Richard Boston and his wife, the first Negro slaves in northern New York. Robinson built a log cabin on the bank of the creek. He was appointed justice of the peace and eventually associate justice of the court of common pleas. In 1815, with Nelson R. Robinson as contractor, he built a sawmill on what became the Saw Mill Creek. Earlier, in the summer of 1804, Daniel's father, Ichabod Robinson, had fallen ill while visiting his son and his daughter Ruth, wife of Elisha Denison. Ichabod died and was buried in Massena Cemetery, and his is the oldest marked grave in Massena.

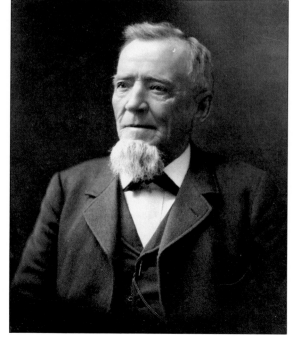

JUDSON L. HYDE (1825–1904). Judson L. Hyde was born in Massena in 1825. Hyde attended the district school during his boyhood years and assisted with farm work at home. At age 10, he loaded up a peddler's cart and started his own business. Later, he attended a select school where he completed his education. He clerked for a time at a store on the Racquette River. Hyde purchased a farm about three miles from the village on Center Street Road. He lived there for 12 years and built a business as a butter and produce dealer. He later gave up farming, moved into the village of Massena, and purchased a house on Main Street and a small store. Hyde and a partner developed the Diamond Creamery.

ABEL HASKELL. Abel Haskell was the son of Lemuel Haskell and Hannah Polley. He was born in 1823 in the stone house that his father owned on Tamarack Street. Abel came into possession of the property after his father died at age 86 in 1870. The house was built of limestone on the site of the first sawmill in Massena. The home remained in the family until World War I, when Alcoa bought it to use as housing for workmen.

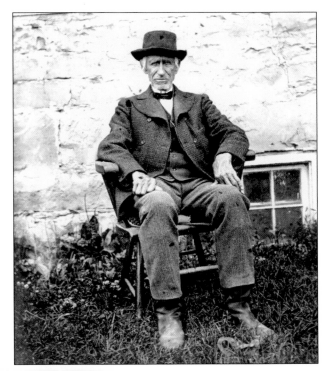

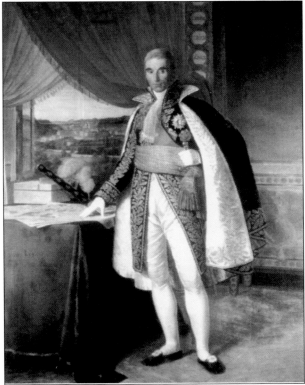

ANDRE MASSENA. Andre Massena was born in the French city of Nice. He became a marshal of France, the Duke of Rivoli, the Prince of Ensiling, and one of Emperor Napoleon's finest commanders. Burning with frustrated ambition and weary of barracks life, Massena quit the army in 1789 to become a shopkeeper in Antibes. A shrewd businessman, he made his work a going concern. Massena was a smuggler who used his first business as a front to mask more profitable activities. He prospered and copied his success by marrying Mademoiselle Lamorre, a surgeon's daughter who had a large dowry. He re-entered the army in 1791. By 1794, he was a lieutenant general with a growing military reputation. After many battles, Napoleon relieved Massena from his command following the loss of the Fuentes de Omeoro battle. Massena died on April 4, 1817, at the age of 59.

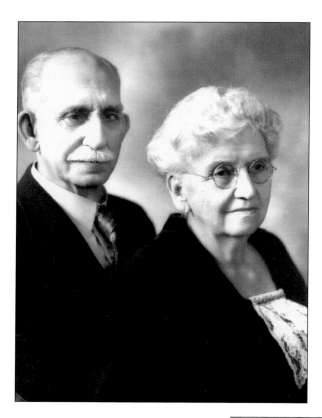

EDWIN AND BARBARA CROWLEY.
Edwin Crowley was born on October 4, 1862, on St. Lawrence River Road near Polley's Bay. He was the son of Royal and Julia Dana Crowley. Julia Dana Crowley was born on Long Sault Island. Edwin and Barbara were married at the home of her parents on September 9, 1885. Mrs. Crowley was later employed at the high school. They had three children.

MAE RICHMIRE. English-language and Americanization classes were started in 1917 at Alcoa. In 1919, the classes were transferred to Pine Grove School, which Alcoa sponsored until 1921, when the New York State Education Department took over. Earlier, in 1911, Mae Richmire became a teacher at the Pine Grove School, and in 1921 she became principal. In 1926, she received high honors from the Bureau of Immigrant Education for her work. It was estimated that the Pine Grove School teachers had helped about 2,000 adult students. In 1952, Richmire received the Veterans of Foreign War Citizenship Medal for her efforts. In 1953, she retired after a 50-year teaching career. Richmire taught at Pine Grove School for her entire career.

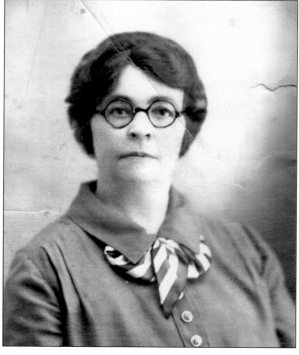

IDA WARREN. Ida Warren was the wife of Henry H. Warren and the mother of Victor A. Warren. Henry Warren conceived the idea of building a canal from the St. Lawrence River to the Grasse River and developing hydro-electric power. The sum of $10,000 was left to the Ida M. Warren Memorial Fund at St. John's Church after her death. Her son Victor was an accomplished businessman. Upon his death in 1947, Victor's estate endowed the funds to build Massena's public library, which became known as the Henry Warren Memorial Building in honor of his father.

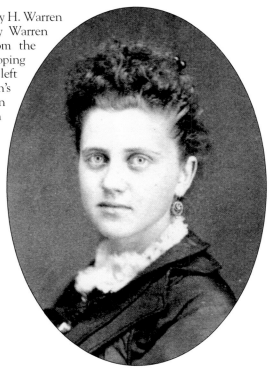

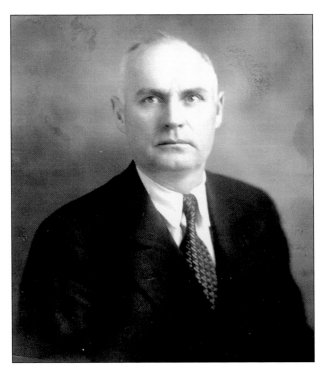

THOMAS S. BUSHNELL. Twice mayor of Massena, Thomas Bushnell was born on December 21, 1889, in Palmyra. An engineer and land surveyor, he came to Massena to work for the St. Lawrence River Power Company. On May 31, 1917, he married Emily Britton of Massena. He served with the Army Corps of Engineers in the 78th Division in France, worked at Alcoa (1919–1929), operated Bushnell Tile and Manufacturing (1929–1937), and served as an airport resident engineer before he returned to Alcoa in 1942. He was elected mayor in the 1930s, village trustee in 1955, and mayor again in 1957, serving three consecutive terms until his death in 1962.

CHARLES CRYDERMAN. Cryderman was born in 1875 in Ontario and came to Massena when he was seven years old. As a youth he worked on the family farm on Long Sault Island and on Croil's Island. Later, he worked for the Reid Plumbing Company and on construction of the Alcoa pot room. Cryderman joined the maintenance department of Massena Public Schools in 1909 and became superintendent of buildings and grounds in 1919. He retired in 1930.

ALLEN P. SILL. Allen P. Sill was born on a farm in Rodman in 1885 and graduated from Watertown High School in 1904. He married Irene Ball of Massena at the home of the bride's parents, Mr. and Mrs. G. W. Ball, at 162 Main Street. The Sills lived at 191 Allen Street for many years, returning later to 162 Main Street. Sill was associated with his stepfather in the Ball Coal Company. Sill was first elected to the assembly in 1940, and was also Massena town supervisor from 1936 to 1942.

LOUIS E. PROVENCIAL. Provencial was born in 1875 in Montreal. The family moved to Bombay when Louis was six. In 1898 he came to Massena to work for the T. A. Gillespie Company on the power canal. In 1904, Louis began working for the New York Central Railroad, and was employed there for 41 years. After he retired from the railroad, he worked for the Harrison Construction Company, which installed the overhead for the Massena Terminal railroad track leading to the aluminum company plants.

RAYMOND T. WHITZEL, VICE PRESIDENT OF ALCOA. Raymond T. Whitzel came from Ohio, where he had graduated in 1914 from Ohio State University with a degree in mining engineering. He started working for Alcoa in 1915 in Niagara Falls. In 1918, he was made assistant superintendent of the fabrication operation in Massena. Whitzel was placed in charge of Alcoa operations in northern New York. In 1953, he became assistant manager of Alcoa's smelting operation division in Pittsburgh, Pennsylvania, and became vice president of the company in 1956. He retired from Alcoa in 1957.

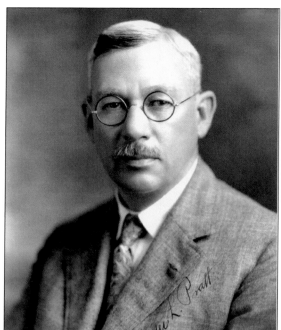

WALTER PRATT. Walter Pratt was born in Lowell, Massachusetts, and came to Ogdensburg as a young man. He was employed at a lumber company and eventually moved to Massena, where he was involved in lumber and building businesses. Pratt built many homes in Massena and became a Republican member of the assembly from the second St. Lawrence district.

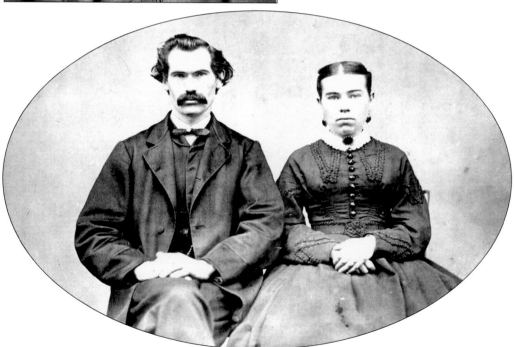

DANIEL AND DELILAH GLENN. Delilah Polley and Daniel Glenn were married in Massena. They never had children and lived alone in their comfortable home on Phillips Street. A quiet and patient man, Glenn ran a shoe store on Main Street. He was tall and stooped from bending over his workbench, and his large capable hands were stained from handling leather. He and his wife both died in 1919.

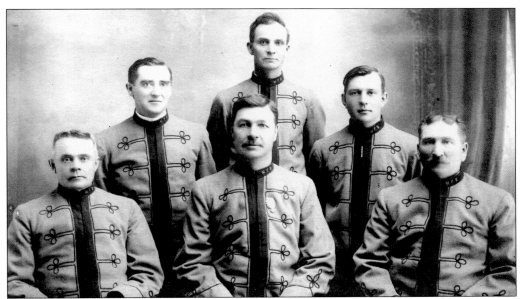

NELSON PHELIX, FIRE CHIEF. Nelson Phelix (seated, center) was born on Croil's Island in 1871, and came to Massena in 1896. He was employed by the Gillespie Company and worked on the construction of the powerhouse. After that, he helped to lay railroad bed. Nelson Phelix spent his life building up Massena. As a carpenter and builder, he constructed nearly 140 homes, including his own at 12 Clark Street. He built four theaters, including the Grand Rialto, Orvis, and Shine. He also constructed the Jewish synagogue and the Congregational, Baptist, Episcopalian, Universalist, and Sacred Heart churches. Phelix built the Old Main Street School addition, the Pine Grove and Harrowgate schools, and much more. He was a firefighter and chief of the Gray Uniforms, and also was the first chief of the Tri-County Association of Voluntary Fire Departments. On one of the darkest days in Massena's history, Phelix piloted the *Cub* to the wreck of the ill-fated *Sirius* and carried seven bodies back to shore.

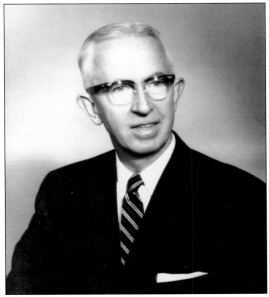

ERWIN G. SCHOEFFEL. Schoeffel was the manager of Alcoa operations at the Massena plant from 1924 to 1942. Schoeffel and Marjorie Sibley were married in December 1926. Erwin Schoeffel was president of Massena Country Club, president of the Men's Club, and a member of the Massena Board of Education. Marjorie Schoeffel was commissioner of the Girl Scout Council, president of the Congregation Guild, and president of the Massena College Club. They retired in 1964.

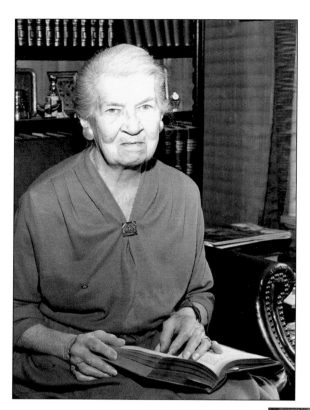

EMELIE BRITTON BUSHNELL. Emelie Britton was born in 1892 to one of the first families to settle in Massena. She graduated from the Massena School in 1910, and went on to earn a degree in music from Oberlin College. She married Thomas S. Bushnell in 1917. Emelie Britton Bushnell was admired and loved by all the townspeople. She died in 1990 at age 98. The Massena Memorial Hospital became a reality through the Bushnells' efforts.

CATHERINE CLINE DODGE. Catherine Cline Dodge was the daughter and niece of the first two men to build and operate a ferry from Fort Covington to Ogdensburg in the 1860s. In 1869, they built a steamboat known as the *Enterprise*. Catherine was born on Long Sault Island in 1856 and married Hiram Dodge in 1872. They operated a farm at Dodge's Landing, the present intake of the Massena Power Canal, until 1897. The power company purchased the Dodges' farm property during the construction of the power canal.

PRESIDENT FRANKLIN D. ROOSEVELT.
Franklin D. Roosevelt visited northern New York on August 17, 1940, to review army troops during air and land maneuvers in St. Lawrence County. He arrived by presidential train in Norwood and then traveled by car along a heavily guarded route. He was accompanied by Secretary of War Henry L. Stimson and Gov. Herbert H. Lehman. Roosevelt had a private meeting with Canadian Prime Minister Mackenzie in a railway car near the U.S.-Canadian border.

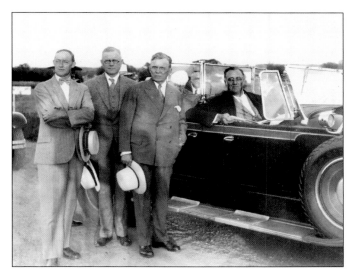

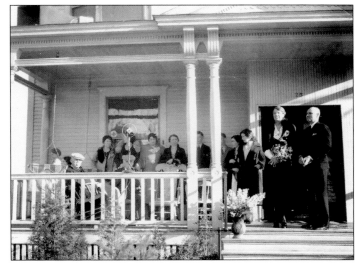

ELEANOR ROOSEVELT. From the porch of the A. B. Cook House on Elm Circle, the First Lady expressed her appreciation to the people of Massena. People filled the streets and Elm Circle Park when the reception was held on May 12, 1933. All local schoolchildren, a total of 2,800, marched to the Cook home. Charles D. Robb led the marching band, and the American Legion also marched in full uniform. They escorted Eleanor Roosevelt to the park to see all of the students.

WALTER BAYER. Walter Bayer, a native of New York City, was employed by E. I. du Pont de Nemours and Company for 21 years. In March 1932, he suffered a breakdown and entered the du Pont College in Saranac Lake, where he met his future wife, a nurse from Massena. They were married at Sacred Heart in Massena in 1934, and moved back to New York City. In 1948, the Bayers moved to North Bangor, and Walter worked for two years at the Tilo Roofing Company. He became civil defense chief between 1955 and 1956. In 1959, he received his diploma in advanced accounting from the International Accountants Society. In 1959, Bayer became mayor of Massena, serving in that office until 1975.

ALBERT "ABBY" SLAVIN. Slavin's furniture business started in an old carriage shed at 10 Water Street with the partnership of Samuel Slavin and Jacob Shulkin in 1913. Two years later, property was bought and, in 1916, the business was enlarged. In 1955, the store was again enlarged to the Grasse River Bridge on Main Street. Shulkin retired in 1956. Abby Slavin continued operating the store for many years thereafter.

ANTHONY ROMEO. Romeo was born in Massena in 1903 to Joseph A. and Catherine Trimboli Romeo. He attended Massena schools and graduated from college in Montreal. Anthony and his wife operated Dixie's Barbecue on East Orvis Street. He became town historian after that. Eventually, the Romeos moved to California. While in California, Anthony wrote a regular column called "Our Town" for the *Massena Observer*.

HAL SMITH (1916–1994).
Harold J. Smith was born in Detroit, Michigan, and came to Massena with his family in 1924. As a teenager, Smith was active in drama productions and sang with Charles D. Robb's high school band. Smith and his siblings held amateur shows every week at the Shine Theater; admission was $5. Hal graduated from Massena High School in 1936. His first job was as a comic and as the "Man of a Thousand Voices" for a popular Sunday radio show on WIBX in Utica. Smith's television career started in 1947. He played Otis Campbell, the town drunk, in *The Andy Griffith Show*. Massena honored him in August 1964, with a Hal Smith Day, when he was presented with his own jail cell.

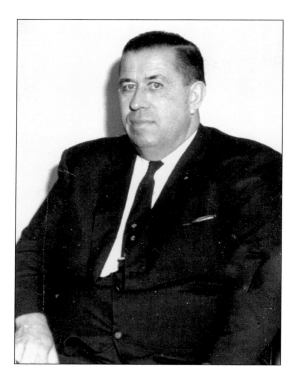

DONALD J. MCKANE (1904–1994). In 1930 McKane came to work for Fregoe's Bakery, and then was employed at Clark's Hardware Store. Beginning in 1933, he worked for Socony Oil (Mobil Oil) for 36 years. In 1951, McKane was elected as a member of the village board and served for four years. In 1967, he was voted Mason of the year. McKane was mayor of Massena from 1969 to 1971.

LEONARD PRINCE (1903–1975). Leonard Prince was born in Fairfield, Iowa. He graduated from high school, and received his degree from Parsons College at Fairfield in 1927. Prince worked for a year as assistant editor of the *Cedar County News* of Hartington, Nebraska, before resigning to take a job with editor L. C. Sutton at the *Massena Observer*. Prince arrived in Massena in 1928 to work as a reporter, and in 1937 he became the editor of the *Massena Observer*, a position that he held for almost four decades. He was married to Helen Farnsworth, who was the society editor of the *Massena Observer*.

WILLIAM J. WHALEN. William J. Whalen graduated from Massena High School in 1937. After taking a six-month postgraduate course, he enrolled in Clarkson College of Technology for two years. Whalen received his appointment to West Point on July 1, 1940. He was sports writer for the *Pointe*, the cadet biweekly publication. He graduated from the United States Military Academy in June 1943. On April 20, 1944, 1st Lt. William J. Whalen was reported missing in action in the north African area. He was on the S. S. *Paul Hamilton*, with torpedoes on board, off the coast of Tunisia. A total of 504 men on board were killed instantly when the ship exploded. He was awarded the Purple Heart.

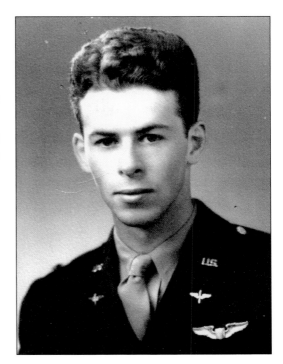

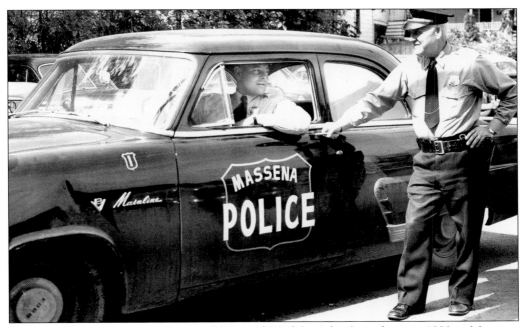

THOMAS O'NEIL, CHIEF OF POLICE. Thomas O'Neil (standing) was born in 1899 in Massena. He attended Massena schools and married Margaret Mahoney in 1932 in St. Patrick's Catholic Church in Hogansburg. O'Neil joined the police force as a patrolman in May 1931. He quickly rose up the ranks to sergeant and was made chief of the force in 1942. O'Neil had worked for 34 years when he retired in 1965. (The officer in the car is unidentified.)

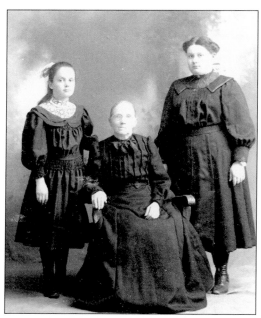

ELLA, MARION, AND AGNES DELANEY. Ella (left) and Marion Delaney (right) lived with their aunt Agnes Delaney Fox (seated). Fox's husband was Capt. James Fox of Waddington. He worked on his ship, the *Sirius*, the day before it capsized in the Grasse River. As an adult, Ella Delaney resided in the Main Street house she was raised in. She was the chair director for many years at Sacred Heart Church. Marion Delaney Bowman became the director, manager, and teacher at Nan Beth Hall, a school for retarded children in Churchville, near Rochester.

GUY B. RUSSELL. Shown are Guy Russell, his wife, Minnie, and their daughter, Laura. Guy Russell was born in Massena in 1860. After high school he attended the New England School of Music. He and Minnie were married in 1882. Guy played the trombone, sang in the choir of the First Baptist Church, and was a bandmaster and a piano tuner. He died in 1939.

Seven

THE POWER CANAL AND ALUMINUM INDUSTRY

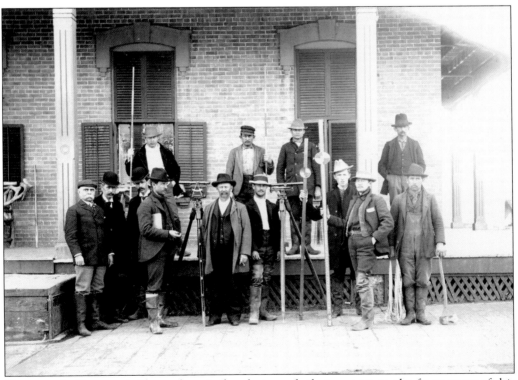

THOMAS A. GILLESPIE. Shown here is the photograph that appears on the front cover of this book. Thomas A. Gillespie is the fifth gentleman from the left in the first row. He is pictured with the other men who worked on the surveying of the land for the Massena Power Canal in 1897. Thomas and his brother were the owners of T. A. Gillespie Company, the construction firm that finished building the Massena Power Canal.

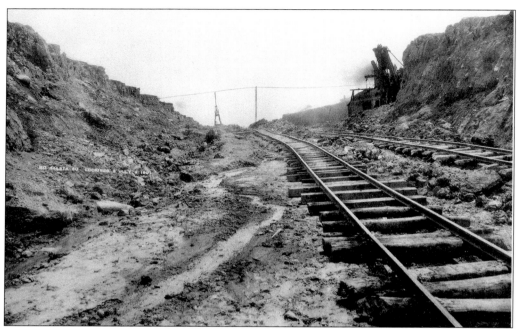

THE POWER CANAL ROUTE AND LANDS CROSSED. The canal takes a southeasterly course from the mouth of Dodge's Creek to the Grasse River, a mile below the village of Massena. The canal is a little more than 3 miles long and is 26.5 feet wide. The sides of the canal slope so it is 187 feet wide at a foot below the water line. There is a slight curve in the water line, almost at a right angle to the Andrew Ridge, and then it flows into a straight line. The course is not pictured here

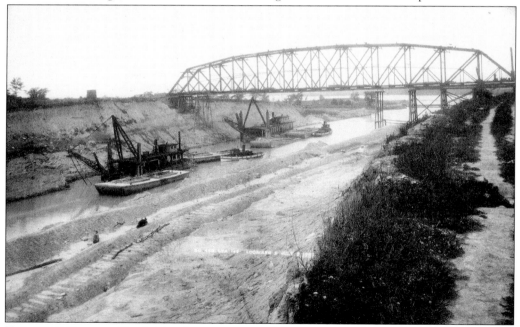

THE HIGH BRIDGE. The bridge that once crossed the power canal was taken down. The piers can be seen from the boat access at the Massena intake landing.

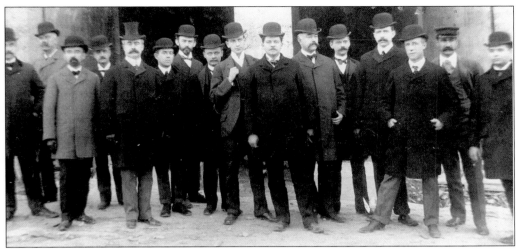

THE OWNERS OF THE POWER CANAL. This picture of the owners was taken on Saturday October 2, 1907. The men included in this image are H. O. Duerr (Lehigh Construction Co.), William C. Lane (St. Lawrence Power Co.), S. H. G. Stewart (St. Lawrence Power Co.), C. H. Reeve (St. Lawrence Power Co.), John Bogart (construction engineer), ? Armstrong (English Board of Directors of St. Lawrence Power Co.), J. D. Broadhead (English Board of Directors of St. Lawrence Power Co.), ? Sweet (general state engineer and surveyor, State of New York), A. C. Rand (Rand Drilling Co.), J. M. Crosby (resident of Boston), C. A. Kellogg (Ogdensburg attorney, St. Lawrence Power Co.), W. R. Zimmerman (Westinghouse Electric Co.), Captain Maud (London stockholder), R. P. Rathburn (Lehigh Construction Co.), Lord Kelvin (investor), and George Westinghouse (companion of Lord Kelvin).

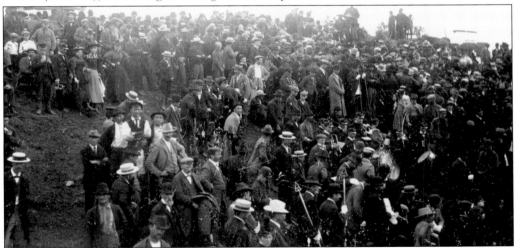

THE FIRST SHOVEL OF DIRT. H. H. Warren was a local engineer interested in a corporation known as the St. Lawrence Power Company. The first shovel of dirt turned over for the building of the power canal took place in the presence of most of the village on August 11, 1897. The T. A. Gillespie Company of Pittsburgh appeared on the scene in June 1898. The job included building two bridges over the Racquette and Grasse Rivers, and abandoning the railroad from the powerhouse site. The excavation of the canal was accomplished by steam shovels, hydraulic and dipper dredges, and tin scrapers. The disposal of dirt was made possible by dump cars, dinkies, scows, and inclines.

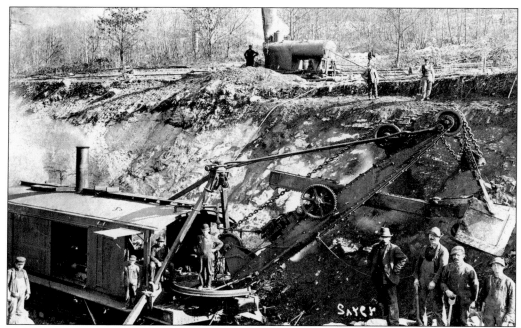

A STEAM SHOVEL. Some of the steam shovels used to dig the power canal were among the largest ever used. Many of them had to be assembled on site and were often positioned on railroad tracks so they could move foreword as the work progressed and, in some instances, were mounted on railroad flatcars. As the name implies, the power source for these giant earth movers was steam. Each steam shovel had to have its own boiler and a separate crew to operate the shovel and boiler, and thus a crew of several men was required to operate each shovel.

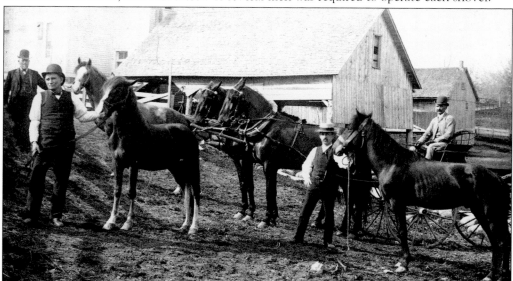

THE POWER CANAL. The power canal project was started in 1897. The canal was dredged and cut to connect the Grasse River and the St. Lawrence River, and the dirt was transported from the site by horse and wagon. The drivers pictured here with their teams are Charles Derby, W. Rollins, George Smith, and John Timerson.

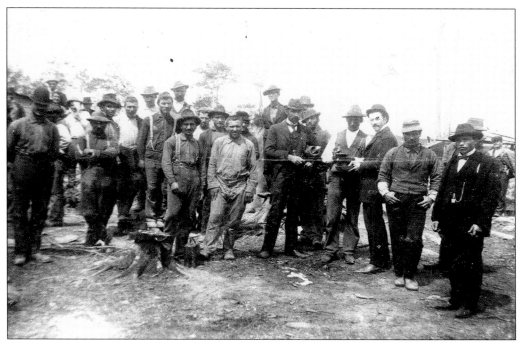

WORKERS ON THE CANAL. Pictured is a typical group of men that worked on the power canal in 1898. These men from Europe saved all their money to send home, so they could bring their relatives to Massena. Some of the countries the workers came from were Italy, Ireland, Poland, Spain, Greece, and France.

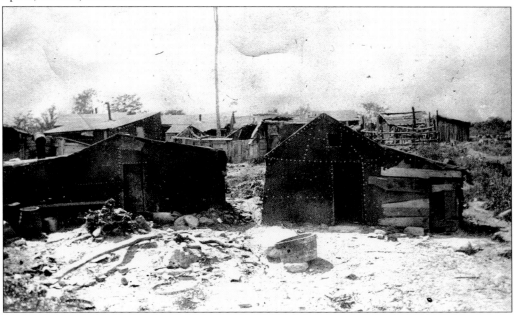

WORKERS' HOMES. Shown are the living conditions of the first immigrants who came to work on the Massena Power Canal. These were some of the camps that the workers built out of scrap material that was lying around the site.

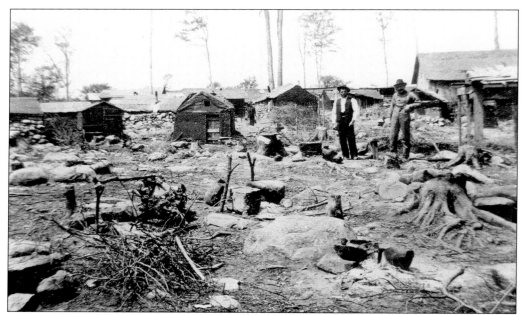

WORKERS' HOUSES. Many immigrants came to Massena from Europe to work on the power canal. Rather than rent rooms, they saved their money to send home to bring their families to America. The workers constructed these tarpaper shacks and sod homes on Andrews Ridge off outer North Main Street, near the power canal.

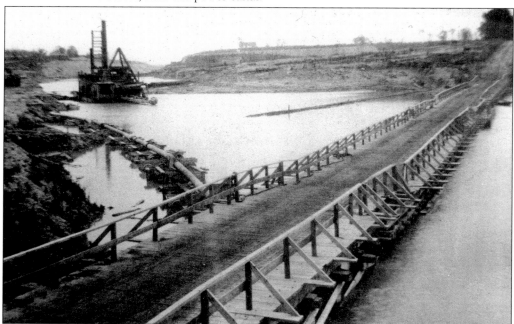

THE PONTOON BRIDGE. The Pontoon Bridge was located on outer North Main Street. At the time the bridge was built it was the longest single-span bridge ever constructed. Today, the bridge has been replaced with a causeway. The original site reveals the debris where the old bridge stood. This was a place where boys from Massena would go to dive off the bridge.

THE YANKEE. This is a picture of the *Yankee* engaged in dredging operations on the Massena Power Canal. The dredge made the first cut in the earth in 1897. This view shows the ice at the north end of the canal between the Pontoon Bridge and the High Bridge.

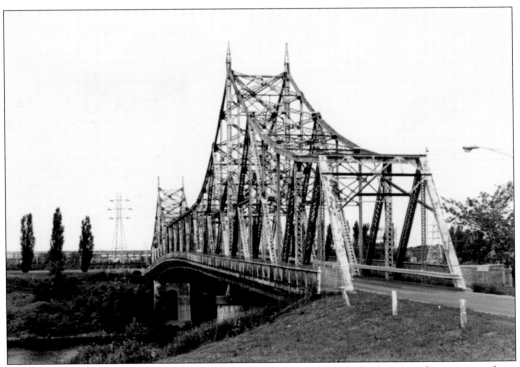

THE OLD ALCOA BRIDGE. This bridge, also known as the High Bridge, was downstream from the powerhouse. It connected outer East Orvis Street with the plant road. Workers traveled it every day to get to and from the plant. This bridge was replaced by a new bridge in 2002.

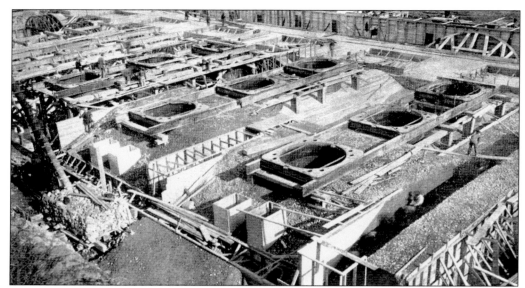

THE MASSENA POWERHOUSE. The powerhouse at the Massena end of the canal is built upon solid rock from the Grasse River and constructed of concrete. At the time it was the largest monolith of concrete in existence, containing about 90,000 cubic yards. It is 360 feet long, about 150 feet wide, and contains seven 6,000-horsepower turbines. The turbines, generators, and switching gear station were purchased from the Westinghouse Company of Pittsburgh, Pennsylvania, for use at the Massena powerhouse.

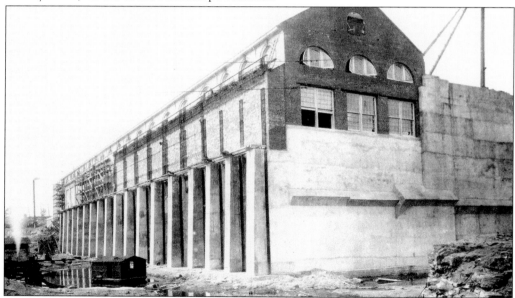

THE COMPLETION OF THE POWERHOUSE. The powerhouse of the St. Lawrence Power Company is located on the north bank of the Grasse River on the edge of the town of Massena. This development makes full use of the fall through the well-known Long Sault Rapids of the St. Lawrence River. A canal takes the water from the south channel of the St. Lawrence, just below the east end of the Long Sault Island and above the rapids. The water passes through the powerhouse into the Grasse River, and from there returns to the St. Lawrence below the rapids.

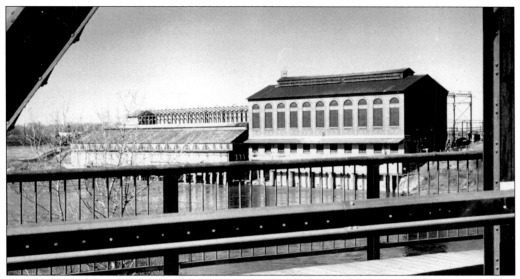

THE FINISHED POWERHOUSE. Taken from the span of the Alcoa Bridge in the 1900s, this picture shows the finished Massena Powerhouse. This powerhouse was essential to the operation of the Aluminum Company of America.

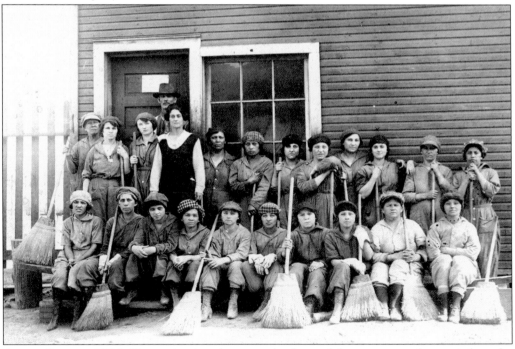

ALCOA LADIES, 1918. Determination shows on the faces of these women who carried on the plant operation when the men were called into service to protect their country. The women held down the jobs and did excellent work in many different departments. These women were known as pot-room sweepers, as is indicated by each woman holding a broom. Lillian Mullen (third from the right in the back row) was the mother of John Mullen, a local man who played a large part in the starting of the Massena Museum.

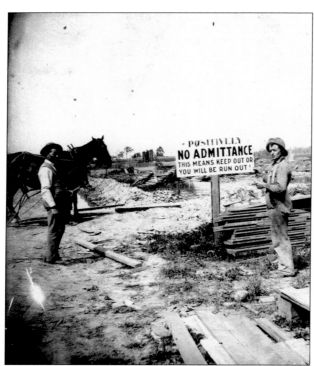

SECURITY AT THE POWER CANAL. Security was tight during the building of the Massena Power Canal. It was made clear from the onset that the owners did not want sightseers visiting the location and possibly moving or disturbing survey stakes that could cause considerable expense as well as loss of time and manpower. Another problem was the theft of construction materials such as lumber and tools.

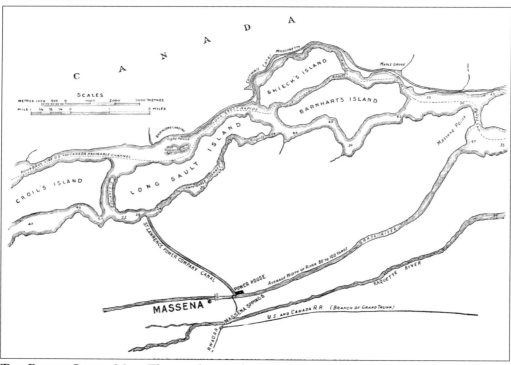

THE POWER CANAL MAP. The canal is 3 miles long, 260 feet wide at the top, 190 feet wide at the bottom, and 25 feet deep. It goes from the St. Lawrence River to the Grasse River.

THE ALCOA GUARD SHACK. The main entrance for the employees to get into the plant was guarded because of industrial espionage. The company also did safety checks of employees that came and went from the plant. During World War II, the security was very tight because of defense contracts. The facility was surrounded with a security fence and was patrolled around the clock by armed guards. It was imperative that nothing interrupt the supply of sheet aluminum and structural aluminum needed for the war effort.

TWO CLASSES OF MEN. This sign was posted outside the main gate of Alcoa during World War II. It was hoped that signs such as this would instill a sense of patriotism and encourage all to do their part to help the war effort.

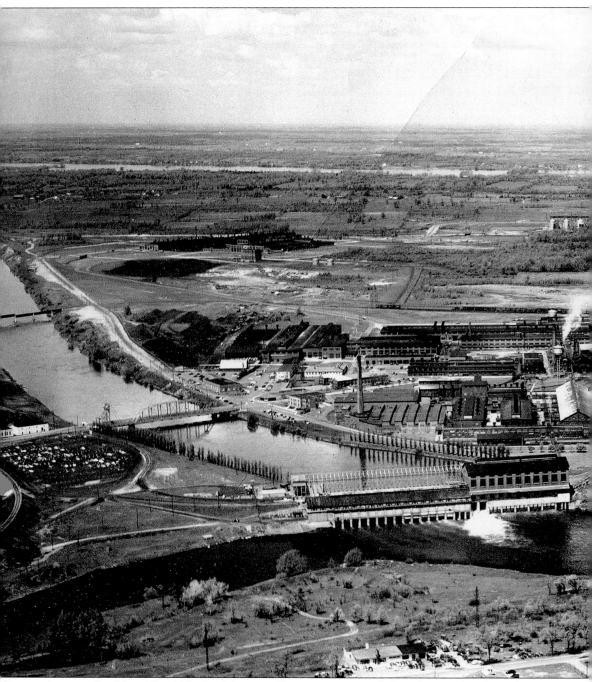

ALCOA. On May 15, 1902, the *Massena Observer* announced that the Pittsburgh Reduction Company, of Pittsburgh, Pennsylvania, had secured the right to utilize the vast hydro power in Massena to produce aluminum. The company's first vice president, Charles M. Hall, discovered the process for making aluminum. Five buildings, each 550 feet long and varying from 100 to 200 feet wide, were erected on 100 acres of land in an area east of the canal and north of the

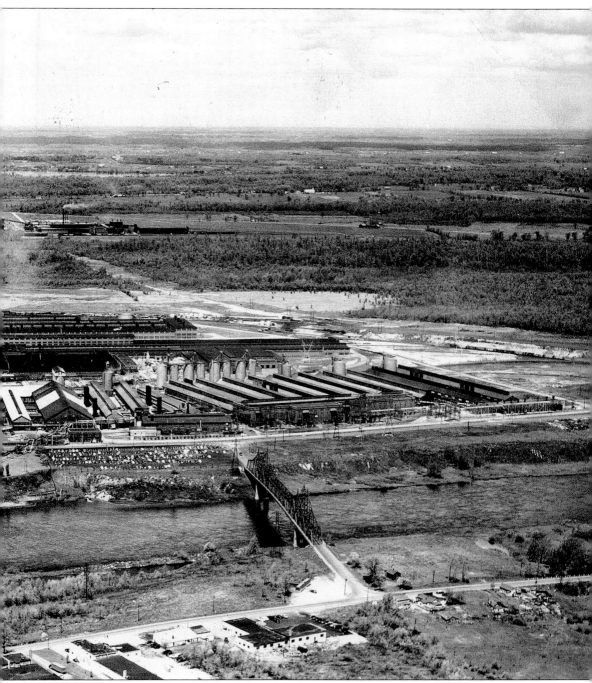

Grasse River. The buildings had concrete foundations and steel framework that was filled in with brick. The plant started with 12,000 electric horsepower. The bauxite came from the company's mines in Georgia, Alabama, Arkansas, and Tennessee. Massena was transformed from a farm and lumbering community into an industrial center.

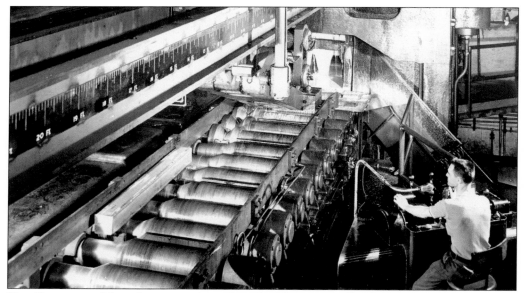

THE BLOOMING MILL. Ingots are formed in the blooming mill. The ingots are first put into preheated furnaces, and the heated ingots are then rolled into plate or sheet by continuously passing through the rolling mills. Plate becomes sheet when it is reduced to a thickness of .249 inches. Both plate (especially for structural applications) and sheet are used in the aerospace, railroad, building, marine, chemical industrial, and military fields.

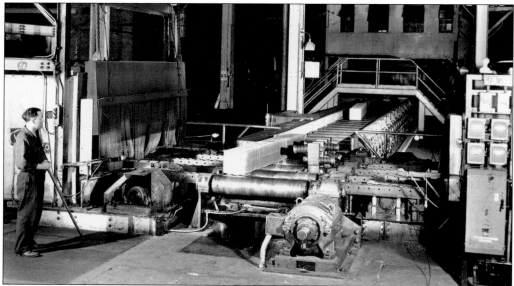

THE POT ROOM. Metallic aluminum is produced by an electrolytic process that separates alumina into its component parts: oxygen and aluminum. In this process, pure alumina is dissolved in a bath of molten cryolite (sodium aluminum fluoride) in large electrolytic furnaces called reproduction pots. By means of a carbon anode suspended in the bath, electric current is passed through the mixture, causing metallic aluminum to be deposited on the cathode, the carbon lining of the pot. At intervals, aluminum is siphoned from the pots, and the molten metal is transferred to holding furnaces and then cast into ingots.

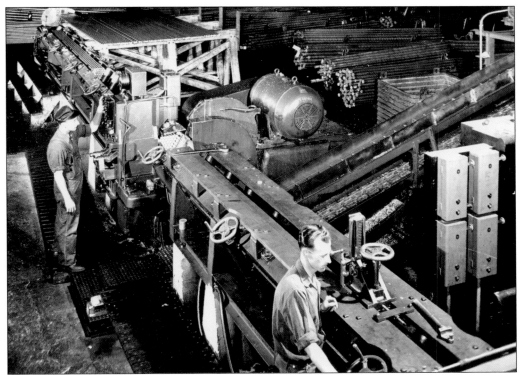

THE MOLDING OF THE RODS. This picture shows part of the fabricating department. The man on the left is operating the switch box for the machine that molds the aluminum raw material into rods. From this machine, rods will go into the rod-sawing machine.

THE SAWING RODS. The rods are then put into the sawing machine, which is shown in this picture. Here the rods are formed into different diameters and lengths. The rods are then readied for shipment to different places. Some of the smallest rods will go to the cable mill to be twisted into wire for coils.

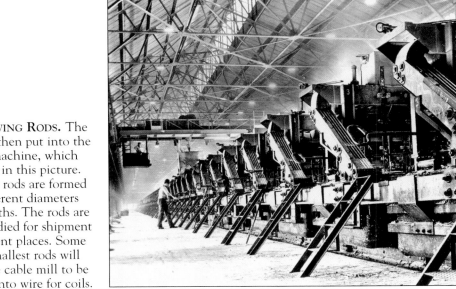

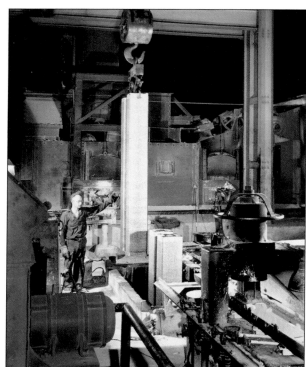

THE REMELT MACHINE. This is a picture of molten aluminum being cast into ingots to be rolled in the blooming mill. These may be made into plate or sheet. Ingots are the starting point of Alcoa's other aluminum products.

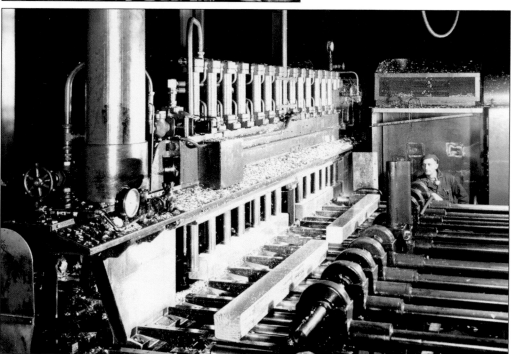

THE INGERSOLL MILLING MACHINE. This picture shows an excellent view of the Ingersoll milling machine. This operation is called scalping. The operator is Ava Jenkins.

BUILDING 140. Building 140 produces aluminum coils, rods, and bars. The building contains the 18-inch rolling mill and the continuous mill. The 18-inch mill produces rods and bars in intermediate sizes. The continuous mill makes coiled rods as well as straight lengths.

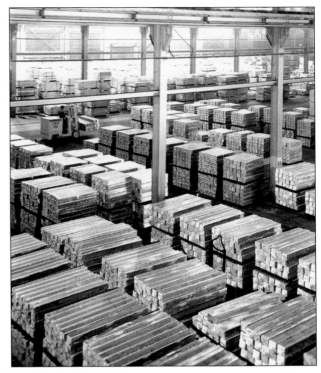

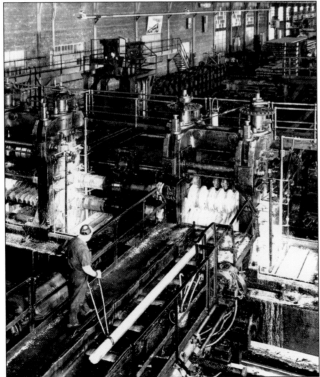

THE STRUCTURAL MILL. This part of the plant was where aluminum rods were brought from the preheat furnace and placed on long roll tables. The rods were then stretched into 12-inch or 16-inch round rods. The mill was discontinued in 1992 at Massena Operations.

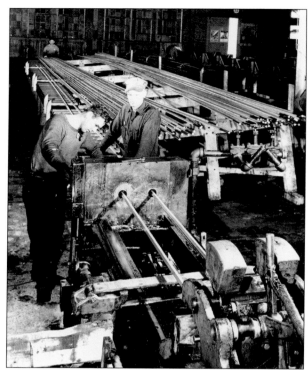

THE MERCHANT MILL. The machines shown here are used to draw wire. The wire-drawing machine used the coil produced in Mill 140 to make fine wire, and then twisted together several strands of fine wire to form cable.

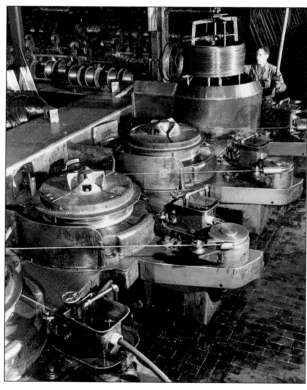

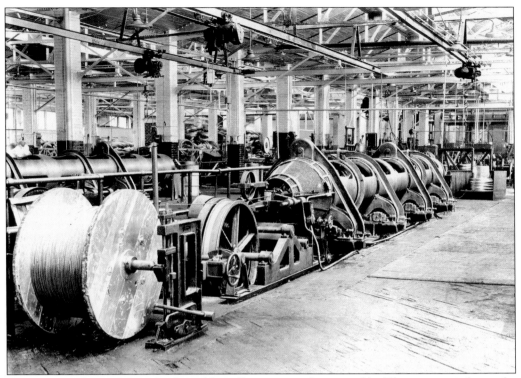

THE ALCOA CABLE MILL. In the cable mill, wire is made into cable. This process is begun by putting several small strands of fine wire into the strander machine, and then twisting it into heavy cable. Endless amounts of cable are turned out month by month and are in service all over the globe. In war as in peace time, the machines pictured here are some of many that maintain the quantity and quality of A.C.S.R. (Alcoa Cable Steel Reinforced) for which Alcoa is known.

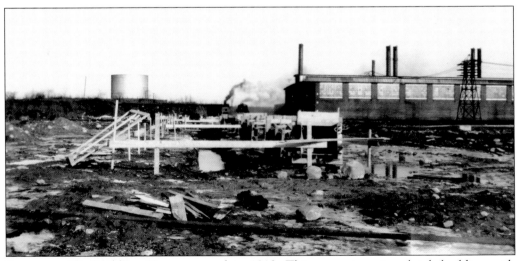

BUILDING 60. Building 60 was erected in 1913. This was a two-story brick building with Vermont-marble trim. This building is used for the main offices at Alcoa.

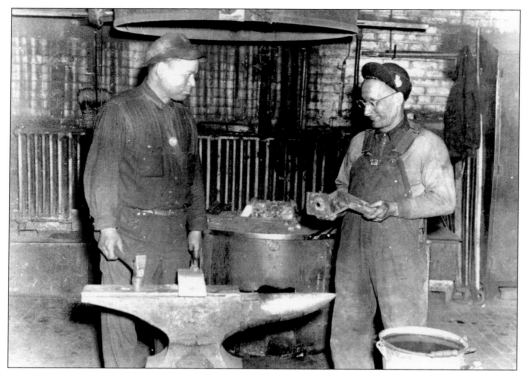

NATIVE AMERICAN WORKERS AT ALCOA. Two American Indians are shown at work in the Massena Alcoa plant. Today, American Indian women, as well as men, make up part of the Alcoa work force. Most of the Native American employees are members of the Akwesasne Nation in Hogansburg.

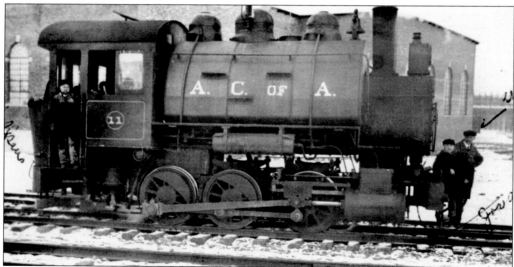

THE ALCOA PLANT TRAIN. Here, you can see the near-gauge locomotive sitting on the track. The locomotive was owned by Alcoa. It served an integral role in the work yard by shifting cars around the yard. The train had a coupler on the back to hook onto the boxcars so they could be moved around.

Eight

THE ST. LAWRENCE SEAWAY

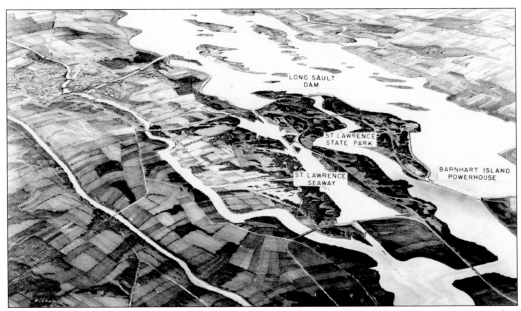

AN AERIAL VIEW OF THE SEAWAY. This is an aerial view of the St. Lawrence Seaway after it was constructed. On the right side in the foreground is the Robert Saunders Powerhouse, which is located on the U.S. side of the St. Lawrence Seaway Project. Today, it is called the Robert H. Saunders St. Lawrence Generating Station. Shown to the left of the powerhouse are the Eisenhower and Snell locks, which make up the U.S. section of the seaway near Massena. Above that is Barnhart Island State Park on the U.S. side, and above the park is the Long Sault Dam, where the mighty Long Sault rapids once roared.

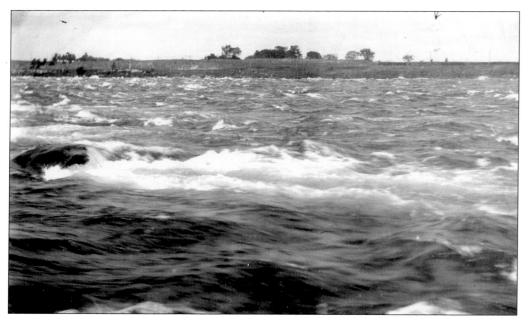

THE LONG SAULT RAPIDS. The rapids were located near Barnhart Island. The water was very dangerous. It was high, cold, and choppy. When the rapids were harnessed, the Robert H. Saunders Powerhouse provided cheap hydro-electric power.

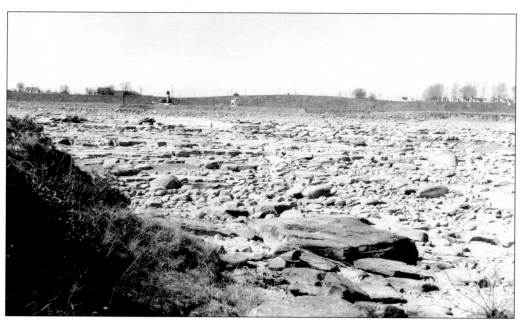

THE LONG SAULT DAM. In the distance is a ship sailing behind the Long Sault Dam in the Cornwall Canal, on the Canadian side of the operation. The canal was a means by which a ship could safely bypass the rapids to sail up the St. Lawrence River. After the water was diverted from this section of the river by a cofferdam and the water was pumped out to create dry land, the areas of rapids were eliminated from the riverbed to create a clear-shipping channel.

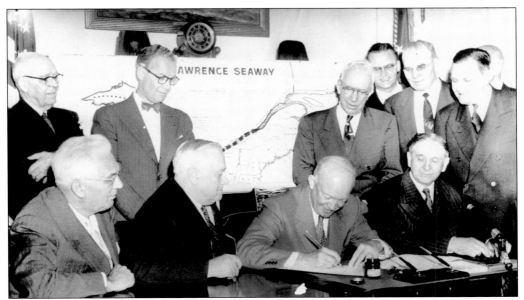

THE SIGNING OF THE SEAWAY BILL. On May 13, 1954, Pres. Dwight D. Eisenhower signed the St. Lawrence Seaway Bill into law. This bill brought ocean trade into the Great Lakes. All these men participated in the White House signing ceremony. Shown seated in this image are, from left to right, the following: Sen. Homer Ferguson (R-Michigan), Sen. Alexander Willey (R-Wisconsin), President Eisenhower, and Rep. George A. Dondero (R-Michigan). Shown standing in this image are, from left to right, the following: Rep. Homer Angel (R-Oregon), Canadian Ambassador A.P.T. Heeney, Sen. George D. Aiken (R-Vermont), Sen. John Blotnick (D-Minnesota), Sen. Edward Thyre (R-Minnesota), and Rep. Clifford Davis (D-Tennessee).

BARNHART ISLAND TREES. These men are cutting down trees to make way for the St. Lawrence Power Project. In the area where the trees were cut, a recreation facility was made. This facility included a pavilion building, toilets, and a picnic area with charcoal grills. The area is used by the Massena Chamber of Commerce as the venue for the Folk Life Festival, an event the Massena Museum participates in each year.

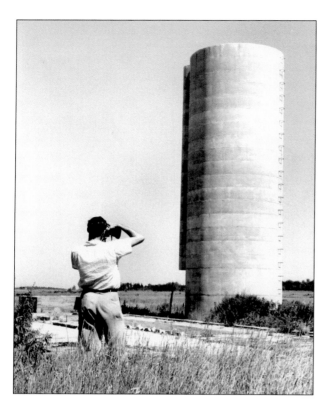

A SILO UNDER WATER. Because of the seaway, the town of Massena prepared for many changes, which meant that some houses and farms had to be moved or they would be submerged in the flooding of the river. This silo was torn down and the land on which it stood is under water today. Roads, churches, and cemeteries were also moved.

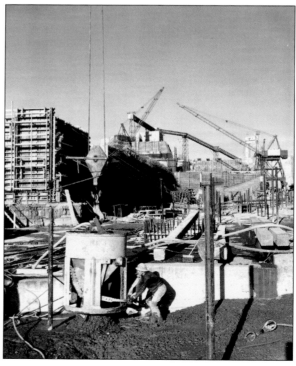

CONSTRUCTION IN PROGRESS. This picture shows concrete being poured for the foundation of the powerhouse. The concrete is being dumped from a large bucket. Before the concrete was poured, the river bed was excavated down to bedrock, and the foundation was fastened directly to the rock to establish a stable base that will never move.

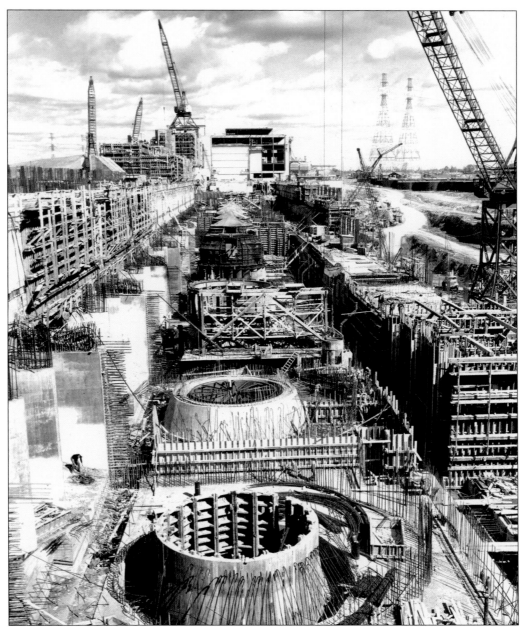

THE POWERHOUSE. This was the construction for the generator units. In the foreground, concrete is being poured into wooden forms. When the concrete sets, the forms will be removed and the turbines will be installed in these openings. Generators will be attached to the turbines, and when the water passes through the dam and spins the blades of the turbines, electricity will be generated. In the background, the pit liners for several generator units can be seen. Three-quarters of the concrete had been poured when the work started on the first generator.

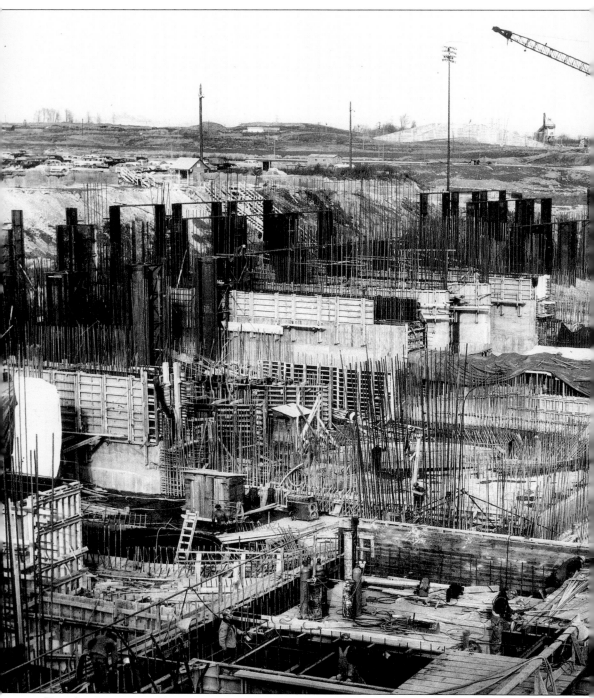

THE ST. LAWRENCE POWER DAM, 1956. This is a view of one section of the Robert Moses power dam under construction. Every concrete structure required wooden forms to be built before concrete could be poured. Hundreds of thousands of line feet of construction lumber was required for the job. Thousands of carpenters and masons worked around the clock, building

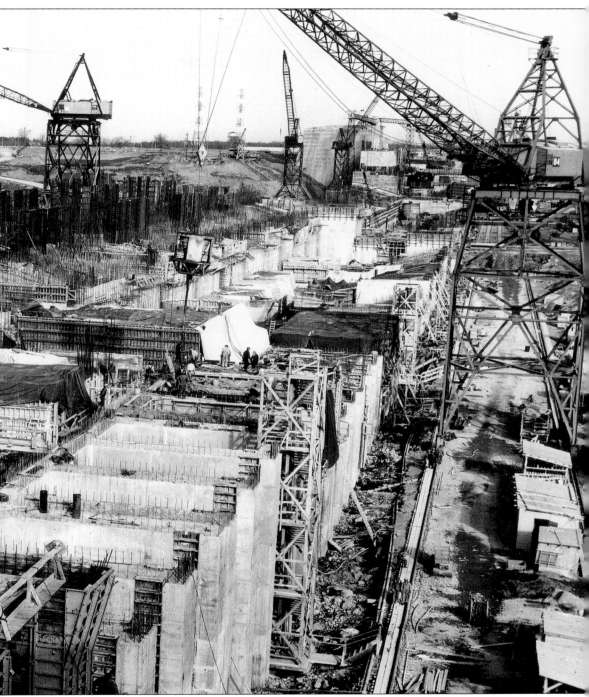

and pouring. The project was an engineering ballet that tolerated little or no delay. By the time the seaway project was completed, more than 192 million cubic yards of earth and stone had been moved, and 5.7 million cubic meters of concrete had been poured. Overall, the project cost $470 million, of which the Canadian government paid $134 million.

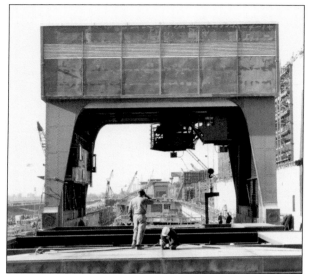

THE GANTRY CRANE. There are two large gantry cranes on each dam. They ride on tracks, and both are capable of traversing the entire length of the dam. The gantry cranes are used to raise and lower the heavy floodgate doors on the dam and thus help to control the water levels on the river. By maintaining the water level at an optimum height, maximum electricity can be generated at the power dam, and the water levels can be lowered during spring to prevent shoreline damage and flooding.

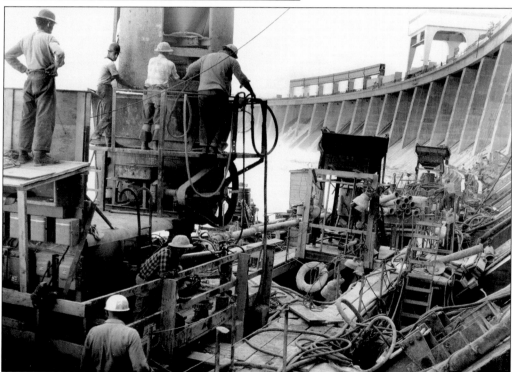

THE LONG SAULT DAM. In order to build the Long Sault Dam, the river was temporarily dammed with cofferdams and the water was pumped out, so that the river bottom could be prepared down to bedrock and the foundations of the dam could be poured. While the river was blocked, water was allowed to flow under the dam through man-made tunnels. When the dam was complete and water was allowed to pass through it in a normal fashion, the temporary tunnels under the dam had to be filled with concrete, as is seen taking place in this picture The dam pool was inundated on July 1, 1958.

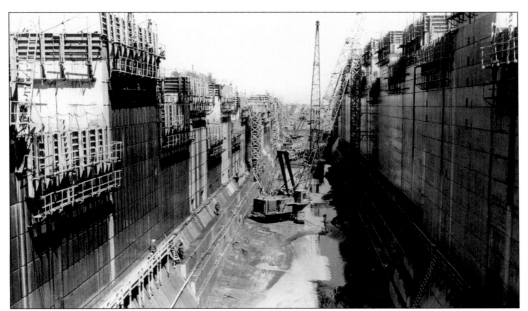

THE EISENHOWER LOCK. The lock system of the St. Lawrence Seaway project is one of the most interesting, yet simple systems of engineering ever devised for the water-transportation system. The lock system has been in use for hundreds of years throughout the world—the Panama Canal system being a good example. As a ship entered the lock at the lower level, a gate was closed and valves opened in the bottom of the lock. Water entered through pipes in the floor of the lock and filled it until the level equaled that of the higher level. When the lock was full, another gate was opened and the ship sailed out, often 30 or more feet above the lower level. Another ship would enter the lock from the higher level and the process would begin in reverse. Amazingly, the system operated entirely on gravity and no pumps were required to move water in or out of the locks.

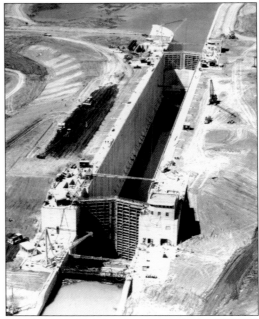

THE SNELL LOCK. Construction of the Snell Lock is nearly complete in this image. There is water between the two lock walls. The gates are closed and the dredges are seen in the background removing the perimeter dike for the channel entrance. The Snell Lock is located downriver from the Eisenhower Lock. There are a total of 15 locks, all with the same characteristics. Each is 766 feet of usable length, 80 feet of usable width, and 30 feet of depth.

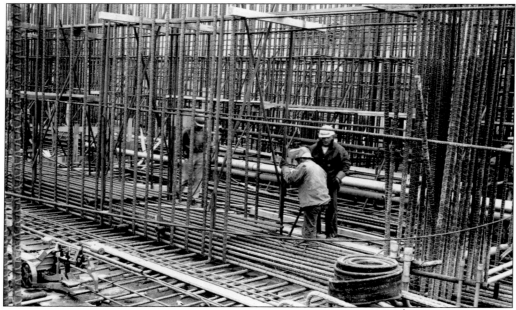

THE CONSTRUCTION AT THE ST. LAWRENCE POWER DAM. Here, three men clad in heavy coats and hard hats are at work amid the jungle of specially rolled, oversized reinforcement bars. These bars are placed at close spacing over ice sluices No. 5 and No. 6 to support the erection bay. The oversized reinforcement bars give the concrete amazing strength and stability. Even if hairline cracks should develop, the concrete could not separate and cause structural failure.

WINTER ON THE SEAWAY. Crews that built the seaway continued their work throughout the winter months at Long Sault Dam, as this photograph indicates. Work progressed around the clock. During construction, this section of New York experienced some of the coldest winters in the previous 50 years. Often, the concrete had to be heated so it would set properly. During construction of the locks, a roof was built over them so work could proceed even in the coldest weather. And above ground, icing became a problem as structures became encased in ice and created hazardous working conditions.

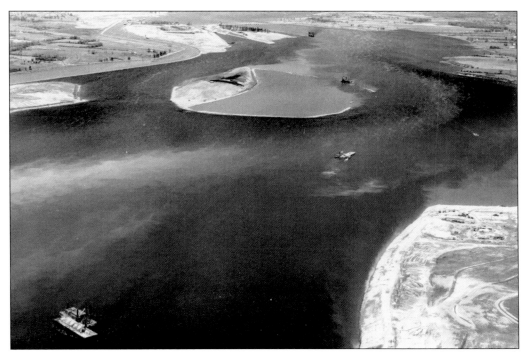

CHANNEL DEVELOPMENTS. Looking downstream from Sparrow Hawk Point in the foreground, the excavation of Toussaint's Island can be seen in the upper middle of the photograph. Iroquois Lock and Iroquois Dam are visible at the upper left of the photograph. In the left foreground are two barges that helped in the removal of earth.

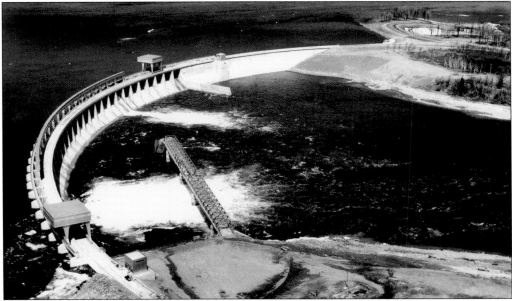

ROADWAY CONSTRUCTION. A roadway was built and pushed out into the water beside the construction bridge. This roadway was built so there would be access for the equipment to remove the structure as needed.

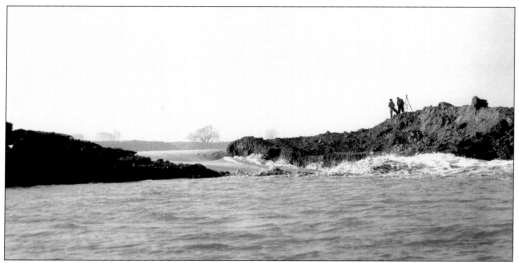

SURVEYORS AT WORK. This picture is a look at the Long Sault Rapids. The surveyors are on the mound of dirt that was pushed out over the rapids so the men could continue to work with the surveying job. The rapids are splashing up against the mound they are standing on. These rapids once roared and nothing could get through them. The seaway project conquered those rapids.

DISTINGUISHED VISITORS. In October 1957, pictured in front of the St. Lawrence Powerhouse site, are the president and the two administrators who oversaw the building of the huge power project. Shown in this image are, from left to right, chairman Robert Moses of the New York State Power Authority, former president of the United States Herbert Hoover, and chairman James S. Duncan of Ontario Hydro in Canada. Hoover inspected both the U.S. and Canadian sides of the project.

HARRY S. TRUMAN. Former President Truman came to check the progress of the seaway power project in 1956. The Eisenhower Lock is on the right.

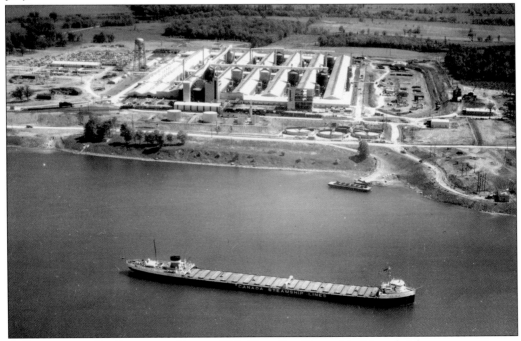

A SHIP IN THE ST. LAWRENCE RIVER. This Canadian Steamship Lines freighter was on its way to Montreal, past the Reynolds Aluminum plant. The ship was headed toward the Snell Lock.

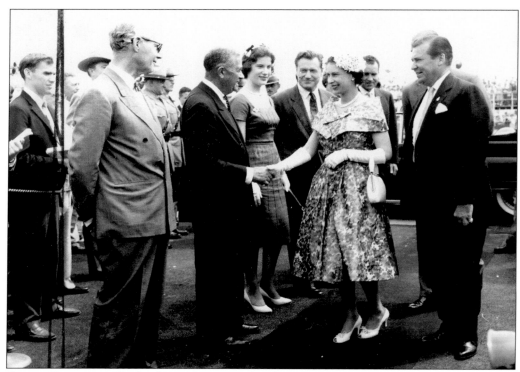

QUEEN ELIZABETH II. On June 27, 1959, a brief ceremony at the center point of the jointly owned dam of the St. Lawrence Power Project was a highlight in the one-day visit of Queen Elizabeth and Prince Philip to the Cornwall area. The royal couple made their first stop on American soil at the St. Lawrence Seaway's Eisenhower Lock, where they were greeted by Vice Pres. Richard M. Nixon and wife Pat Nixon, Chairman Robert Moses of the Power Authority of the State of New York, and other distinguished Canadian and U.S. citizens.

THE INTERNATIONAL FRIENDSHIP MONUMENT. The royal couple then visited the downstream side of the adjoining Robert Moses Power Dam and Ontario Hydro's Robert H. Saunders St. Lawrence generating station. Queen Elizabeth was accompanied by Vice President Nixon and wife Pat, Prince Philip, and other guests for the second ceremony: the unveiling of the International Friendship Monument (seen at center).

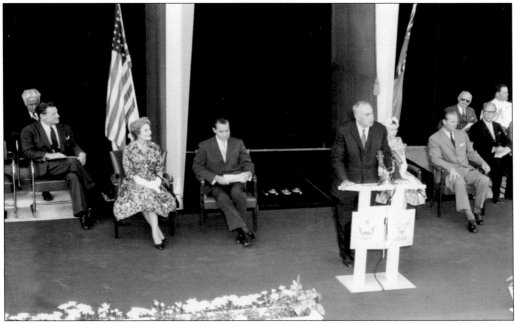

THE UNVEILING CEREMONIES. At the conclusion of the ceremony, the chairman of the Hydro-Electric Power Commission of Ontario, James S. Duncan, presented a miniature golden replica of the International Friendship Monument to Queen Elizabeth, while Robert H. Moses, chairman of the New York Power Authority, made a similar presentation to Vice President Nixon. Also in attendance were New York Gov. Averill Harriman, Robert Moses, and Prince Phillip.

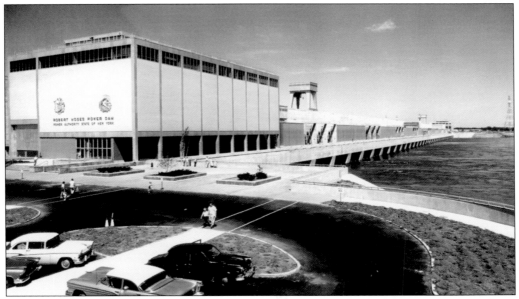

THE ROBERT MOSES POWER DAM. The visitors center at the Robert Moses Power Dam closed to the public in 2001. Families and school groups used to go to the observation deck to watch the water flowing through the dam gates. A famous mural by Thomas Hart Benton is in the third-floor lobby.

INSIDE THE POWER DAM. Shown is a working model of the power dam that was on view for the public on the observation deck of the administration building. A taped commentary described its operations.

IN THE TUNNELS. Pictured here is an employee riding an electric cart in the 1,300-foot-long turbine gallery (the U.S. section) in the Robert Moses Power Dam. The tiled floors of the building were waxed and polished daily.

Nine

AROUND TOWN

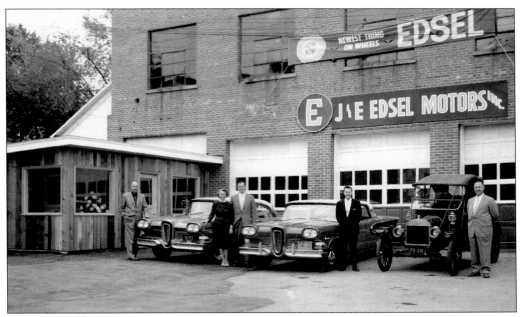

THE EDSEL GARAGE. The Edsel Garage was located near the intersection of West Orvis and Main Streets in the early 1950s. It was opened by John and Elmer Boyce. The Edsel car was short-lived, but was quite a novelty. The model did not last long, due to the lack of interest from the American public. The Boyces purchased a building on outer East Orvis Street c. 1958 and sold Ford cars. From 1942 until 1958, John Boyce ran the only bus line that operated in the area. John Boyce Bus Line was instrumental in transporting many out-of-town Alcoa workers to and from the workplace. (Courtesy of Pauline Boyce.)

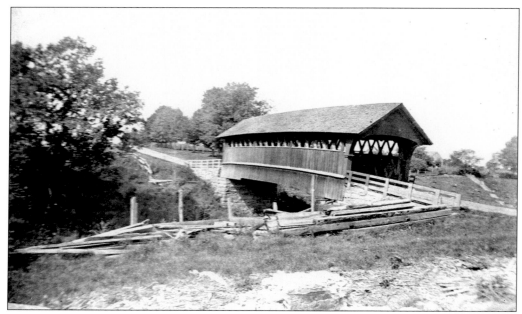

THE COVERED BRIDGE. This old covered bridge was located in Massena Center and was built around the time of the Civil War. The bridge was constructed of hand-hewn logs from the nearby forest and hand-sawn timbers and planks. Because most bridges of this type were built low to the waterline they often were washed away in spring floods.

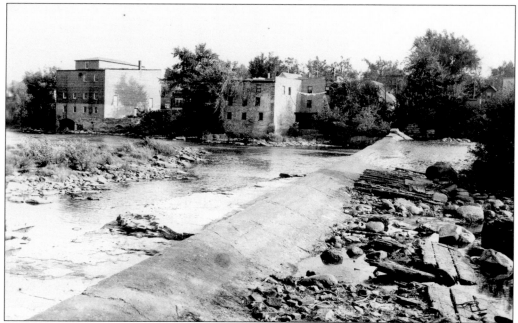

THE DAM ON THE GRASSE RIVER. This dam is fairly typical of dams built throughout Europe and America in the 1800s. They were usually rock-filled, timber-framed structures. The back of the dam had an angled deck built of timbers in order to allow ice and debris to slide over the dam without causing a jam.

THE MASSENA OBSERVER. The newspaper was started in 1891 in a single room behind a store next to the town hall on Main Street. Through many owners, the paper's office stayed in the original location until it moved to a new home on Route 37 in 2002.

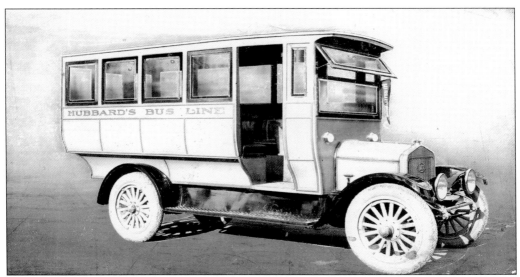

THE HUBBARD BUS LINE. The Hubbard Bus Line was located on Maple Street in the village of Massena. The buses ran a regular schedule, leaving Massena in the morning and going to Malone and Ogdensburg, and in the evening the route was reversed from Ogdensburg to Malone and back to Massena. Built almost entirely of wood except for the iron undercarriage, each bus could carry five to seven passengers.

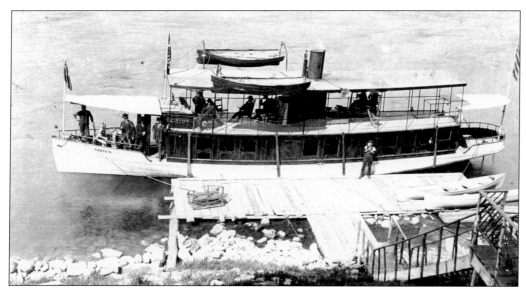

THE STEAMER SIRIUS. This steamer was owned and managed by Capt. Weston U. Cline. The boat made two trips each day. It left from the shipyard of the aluminum company, on the bank of the Grasse River at the eastern edge of the village. The steamer ran to the mouth of the Grasse River, about eight miles below, then up the St. Lawrence to Massena Point, about one mile, and across the St. Lawrence to Cornwall about three miles, traveling a total of 12 miles.

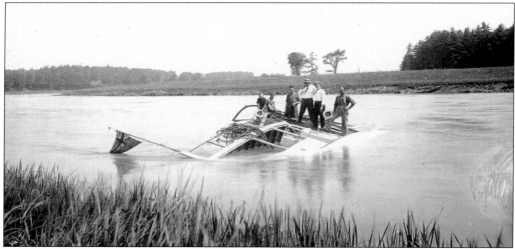

THE SINKING OF THE SIRIUS. On August 1, 1919, shortly after picking up two passengers at Brewer's Landing near Massena Point, it was necessary to swing the steamer *Sirius* around. At that point, a muskrat swam out of the reeds. All the passengers left their seats and rushed to one side of the boat to see. The boat got caught in the swift current and capsized, throwing the passengers into the water. Capt. Weston Cline, owner of the boat, had shouted to the passengers to remain in their seats, but no one listened. Seven people lost their lives in the accident: a bookkeeper, a public school teacher, an assistant librarian in the Massena Public Library, a seven-year-old boy, a Hungarian woman living in Massena, E. R. Firth of Ontario, a sister of F. M. Burley of Massena, and Frances Fregoe, daughter of H. Fregoe of Massena. The anchor of the *Sirius* was retrieved and was donated to the Massena Museum by the Cline family.

THE MASSENA COUNTRY CLUB. This is a picture of Massena's first country club, established in 1903. The property where the country club was located was formerly the Talcott family farm. The course was laid out along the south shore of the St. Lawrence River about three miles northwest of the village of Massena. The clubhouse offered a splendid view up and down the St. Lawrence for miles in either direction. Golf enthusiasts purchased the building, and work on the course and the clubhouse started.

THE ANDREW STREET PARK. The 10-acre parcel of land for the park was donated by Gertrude Newton, a descendant of Shadrack Waterbury, and in whose family the land had been held since 1804. Waterbury owned land on both sides of the Grasse River. The property on the Maple Street side of the river was donated as a site for construction of the hospital.

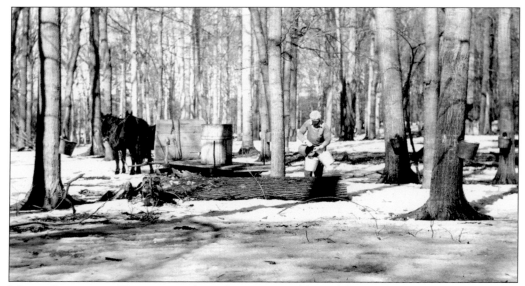

MAPLE SUGARING. This picture shows how sap is calibrated for maple syrup. Workmen bore tap holes in the trunks of trees, and then insert a spout so that a watertight seal is made with the sapwood and the bark. They then hang plastic bags or galvanized buckets on the spouts to collect the sap; the buckets are covered to keep out rain and falling debris. The sap is transferred to storage tanks. In the evaporation house, the sap is boiled and the water evaporated off to concentrate the syrup and flavor. When the proper consistency is reached, the syrup is cooled, bottled, and marketed.

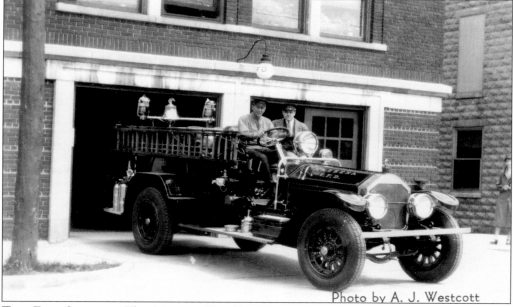

Photo by A. J. Westcott

THE FIRE STATION. The Massena Fire Department was organized March 12, 1900. On March 20, 1900, the taxpayers of the village voted to spend $680 to purchase a hose reel and other equipment. The bell of the Baptist church was used as the fire alarm until 1916. In that year, the first motorized truck was purchased as well as a new fire alarm system.